THE HUMAN FIGURE

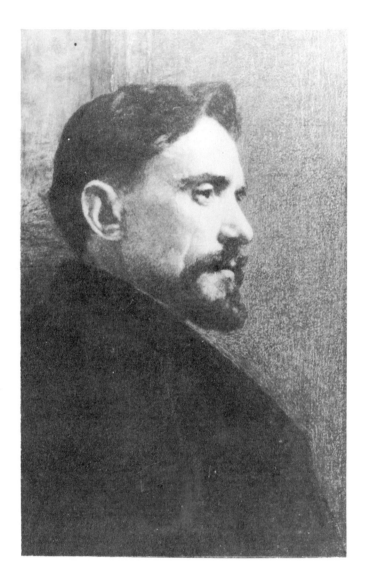

John H. Vanderpoel

John H. Vanderpoel

THE
HUMAN
FIGURE

Dover Publications, Inc., New York

Published in Canada by General Publishing Company, Ltd., 30 Lesmill Road, Don Mills, Toronto, Ontario.
Published in the United Kingdom by Constable and Company, Ltd.

This Dover edition, first published in 1958, is an unabridged and unaltered republication of the last revised edition of 1935. This Dover edition is published through special arrangement with the original publisher, Sterling Publishing Company, and Mrs. Neilson M. Mathews.

Standard Book Number: 486-20432-4
Library of Congress Catalog Card Number: 57–14883

Manufactured in the United States of America
Dover Publications, Inc.
180 Varick Street
New York, N. Y. 10014

FOREWORD

◇

Mr. John H. Vanderpoel approached nature in a direct and simple manner, his impressions faithfully recorded are examples of his understanding of the human figure of which this book is a living record.

This insight into nature was the result of a lifetime of earnest, patient and persistent study. He analyzed and recorded the human figure both in mass and detail; in good taste and discriminating judgment, with a closeness to nature that has never been equaled. The features; eyes, nose and mouth will always remain a masterpiece in art.

Mr. Vanderpoel also had a clear and defined style, built up by infinite labor, as thousands of pencil drawings in existence show and illustrate his method of study.

The representation of these drawings will not change with time. Mr. Vanderpoel has left behind him a great and powerful influence. True art is not subject to period changes.

GEORGE B. BRIDGMAN

CONTENTS

◇

FULL PAGE ILLUSTRATIONS

◊

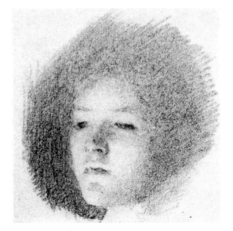

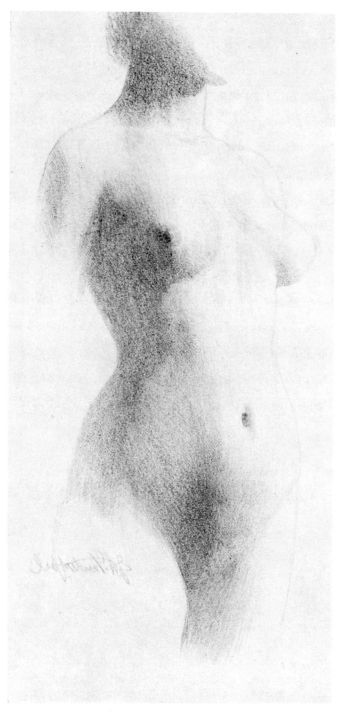

DRAWING THE HUMAN FIGURE

◇

S UCCESSFULLY to build up the human figure
in a drawing, painting or statue, either from
imagination or from a model, the artist or sculp-
tor must be possessed of a keen sense of construc-
tion.

The human body, with its varied beauty of con-
struction, character and action, is so complex that
it is essential for the student, artist and sculptor
not only to have a clear knowledge of its intricate
forms, but a comprehensive understanding and a
habit of simple treatment in order to apply this
knowledge to its artistic end.

The artist is immediately concerned with the ex-
ternal and the apparent. He views nature as color,
tone, texture and light and shade, but back of his
immediate concern, whether he be figure painter
or illustrator, in order to render the human form
with success, he stands in need of skill in the use
of his knowledge of structure, of his understanding
of action and of his insight into character. These
things require a period of profound academic
study.

When we consider the infinite variety of action
of the human form, its suppleness, grace and
strength of movement in the expression of the
fleeting action, and farther consider that the sur-
face of the body is enveloped in effects of light and
shade, iridescent color and delicate tone, it is not
to be wondered at that the student's eye is readily
blinded to the hidden construction of the form.

At this stage of the student's advancement a careful study of artistic anatomy, as elucidated by Richter, Bridgman or Duval, familiarizing him with the bony structure of the skeleton, and the location, attachment and function of the muscles, will not only be helpful in furthering his own research, but will enable him the more readily to understand the theory of construction of the human body as presented in this book.

The theory of construction of the human figure here presented is based on the pictorial means usual in the expression of the solid, that is, the expression of the three dimensions—length, breadth and thickness — by means of planes. In the simple drawing the boundaries of these planes may be indicated by lines of varying weight, and in a tone drawing by the varying depth of the values. It is the discovery or search for the relative position, character and value of these planes that will engross our attention in the ensuing chapters.

In the making of a thorough drawing of the human body, involving a sustained effort on the part of the student, whether in line, light and shade, or tone, the student goes through two stages of mental activity: first, the period of research, in which he analyzes the figure in all the large qualities of character, action and construction. In this analysis he acquires an intimacy with the vital facts, and this leads, as the work progresses, to a profound conviction. When thus impressed the student enters upon the second period, which deals with the representation of the effect dependent upon light and shade. Impressed with the facts in regard to the character of the model, understanding the action and construction, his appreciation enhanced by research, his lines become firm and assertive.

In the first period the student's mind is engrossed with the search for the relative place the part shall occupy in conveying the impression of the whole; having secured the position of the part, the second period is occupied in turning the place for the part into its actual form.

The artist's or illustrator's final objective is the pictorial, and he uses any and all technical means and mediums to that end. He studies theories of color, perspective, effect of light and shade, values, tone, and composition; all may be studied separately and exhaustively so that he may learn the full import of each—so, too, the matter of form should be studied for its own sake. Every stroke of the artist's brush should prove his understanding of the form of the subject-matter depicted; this includes insight into the character of the model, understanding of his action, and how the form is put together.

A figure posed in a full light, with its multitudinous variety of high lights, half-tones and shadowed accents, does not disclose its structural nature to the uninitiated student; it does not appeal to him as he stands dazed before it, for there is so little of shadow to go out from. Preferably he chooses a position where the effect of light and shade is strong, not because the construction is more evident, for the figure may have been posed only incidentally to that end, but because the strong effect appeals to him for his work with black charcoal upon white paper. In order that the student may the more readily understand the construction of the figure, as analyzed in the accompanying drawings, its parts and the whole have been so lighted as to show, through the effects produced, the separation of the planes that mark the breadth,

front or back, of the form from its thickness. In this illumination the great masses or planes that mark the breadth relative to thickness of the human form are made plainly visible. Such illumination divides the planes that envelop the body into great masses of form which upon analysis disclose its structural formation.

The student must learn early to form a vivid mental picture of his model, and the first period of the development of his drawing is but a means to enhance this mental picture through profound research. This mental picture must include the figure in its entirety, so that no matter what minor form the eye may be attracted to or what line the hand may trace upon the paper, the nature of the relationship of the part to the whole may first be established.

An exhaustive line drawing made upon constructive principles, including understood action and strong characterization, will give added quality to the tone and light and shade of the student's work. It might well be suggested in the development of the student's skill as a draftsman that he vary the means according to the end required. Besides the outline drawing suggested above, he might venture into tone by smudging the paper with a value of charcoal and removing it for the masses of light with the fingers or kneaded rubber. Again a period may be spent in swinging in the action, proportions, and construction of the figure with long lines, and also in making quick ten or fifteen minute sketches. These efforts in connection with sustained work requiring a number of days for completion, which means the carrying forward of a drawing from the blocking-in stage to the complete effort, including tone, are commended to students.

Great skill in draftsmanship is highly desirable, but the student should be warned not to give it his sole attention for too long a period. He should test his skill and knowledge by memory drawing and by applying them to composition.

John H. Vanderpoel

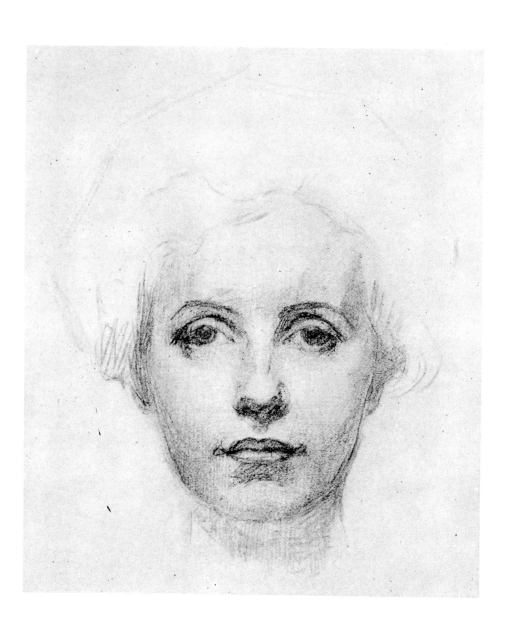

THE EYES

◇

BEFORE taking up the study of the planes which form the structural solidity of the head, the features and their environment may well be analyzed separately. However, the student must fully realize that no matter how intimate his knowledge of a part may be, it is only of value when it coexists with an appreciation of its relation to the entire structure.

The eye, or any part of the human figure, must, be truly placed and bear a true relation to the larger planes. A degree of knowledge of the inner construction of a part is absolutely essential, but this knowledge becomes significant only as its effect on the external form is made manifest in truthful relation to other parts.

The eyeballs enveloped by the lids protrude partially from their bony orbits. The plane of the orbits or sockets slopes inward from the frontal bone as it descends, making a decided angle with the plane of the forehead and cheek, giving the effect of the forehead being a step in advance of the plane of the cheek. The sockets are somewhat rectangular in form, and descend slightly from the nose outward; this drooping effect in the skull is counteracted in the living model by the eyebrows as they rise from their origin to the outside of the socket.

From this orbit or concavity, the convex or spherical form of the eyeball, with its enveloping lids, presses outward, but rarely extends sufficiently to disturb the inward slope of the plane in which it is contained.

[17]

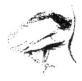

Open or closed, every part of the eye, and its immediate surroundings, tends to the preservation of this plane; the eyebrow protrudes beyond the orbicular muscle below it, which in turn overhangs the upper lid; the upper lid, in virtue of its thickness, projects from the cornea, the exposed portion of which slopes slightly downward, and this slope is greatly increased when the eye looks downward; the lower lid, thinner than the upper, terminates the orbital plane in its contact with the cheek.

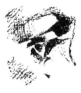

A plane formed not unlike a keystone, facing slightly downward and similar in direction to the orbital plane, descends from the center of the frontal bone, connecting the forehead with the nose and separating the eye sockets.

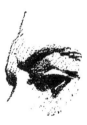

The eyebrows originate at the sides of this keystone, and together mark the lower boundary of the plane of the forehead. Rising, in part from underneath the frontal bone and where it is heaviest, the eyebrow travels outward and a trifle upward, diminishing in width until at the approach of the temple it turns upon the outside of the bone, following the arch along the temporal border of the orbit to its termination. In describing the arch of the orbit the eyebrow makes a half turn upon itself like a spiral curve.

Having studied the orbital plane and the manner in which it affects its contents, the eye itself may be further considered. Directly below the eyebrow, from the point where it turns to the outer surface of the bone, is found the orbicular muscle, filling the space between the eyebrow and the upper eyelid, leaving the inner portion of the orbit depressed. This is indicated by a triangular shape of shadow on each side of the junction with the nose, when the head is fairly lighted from above.

Below these retreating forms, that is, below the deep bony depression just above the inner corner of the eye and the convex muscle immediately above it, the eyeball, enveloped by the lids, presses slightly forward. The eyeballs being considerably smaller than the cup from which they protrude, cause the corners of the eye to set well within the border of the orbit, so that the outer corner is found, steplike, well inside the plane of the temple; the outer corners also retire more deeply than the inner.

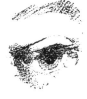

Starting at the base of the nasal bone, the eyelids have their origin at the inner corner. The corner itself, located between the ball and the nose, is in the plane of the face, being unaffected by the convexity of the ball. The upper lid rises abruptly from the inner corner, and sweeps with graceful curve over the spherical form of the eyeball to the outer corner, while the lower lid starts continuously with the direction of the lower border of the corner, curving but slightly until it sweeps upward to the upper lid, which overlaps it. The inner corner of the eye is farther forward than the outer, so that a section of the exposed portion of the eyeball from corner to corner would slope backward from the center of the face; this enables the eyes to swing sidewise for observation without turning the head. The outer corner also is somewhat higher than the inner.

The upper lid folds upon itself so strongly that it becomes a distinct form when the eye is open, widening from the corners to the middle and extending beyond the ball a distance equal to its thickness, which is greatest in the center. The lower lid, being capable of but little movement, is more softly defined as it comes in contact with the cheek. The upper lid is thicker than the lower, as it must

be to support the heavy lashes as a protection and screen to the eye. The thickness of the upper lid and weight of lashes have much to do with giving depth and mystery to the eye through their shading.

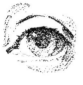

When working in masses of light and shade and tone, the eye, as enclosed by the lids containing the pupils, iris and white of the eye, had better be kept well in tone, from which the value of the white of the eye should be lifted, care being taken not to make it too white, and also the catchlight on the cornea of the iris should be lifted in the same way. In section the lids are slightly but reversely beveled from front to rear, and fit snugly in contact with the ball.

The eye possesses free rotary movement, and as each change signifies a readjustment of the lids over the ball, an intimate structural knowledge is necessary in interpreting varied action. The iris is covered by the cornea, which is raised from the ball, forming part of a smaller sphere, and as the iris in ordinary vision is lapped over well-nigh a third of its diameter, the cornea affects the form of the upper lid delicately, raising it slightly in whatever direction the cornea is turned. The circular form of the pupil found in the center of the iris is rich and dark in tone, being greatly affected in life by its dilation or contraction.

The draftsman's problem in conveying a pictorial representation of a living form lies in his understanding of the structural form depicted. The drawing of a symmetrical inanimate form in a simple view presents difficulties of its own, but when we change symmetry to diversity, transform the inanimate to the living in action, and add the complications that come through choosing a point of view which involves foreshortening, the artist's

structural knowledge is keenly taxed. In truth, strength of draftsmanship lies in the degree in which structural form is understood.

In strong illumination, it is readily seen what portion of a form belongs to one plane and what belongs to another, at least as far as the big planes which are at right angles are concerned.

In the three-quarter view of the eye-socket and eyes, every form sets back of the plane of the orbit. The eyebrows come well from underneath the frontal bone and rise to the outside at the approach of the temple. Observe the fullness of the orbicular muscle as it overhangs the eyelid, and the eyelid as it projects beyond the ball.

The variety of curvature in the lids not only because of their own character but also as expressed in the three-quarter view, emphasized by the eyes looking out of the corners. The apparent difference in the outer corners as the lids come together, the corner of the nearer eye being quite angular, whereas in the corner of the farther eye, the lids together describe the convexity of the ball perfectly. The tendency of the cornea to raise that part of the upper lid under which it rests.

The great thickness of the upper lid fringed with its heavy lashes shades the upper part of the iris and gives added depth and beauty to it.

In the three-quarter view of the eyes the irises are raised above the level, showing an amount of the white of the eyeball below them. The iris in the three-quarter view becomes oval, and when the eye is raised slopes in an opposite direction to the plane of the orbit.

In the spiral turn of the eye the lids upon the ball is particularly noticeable in the upper lid; the

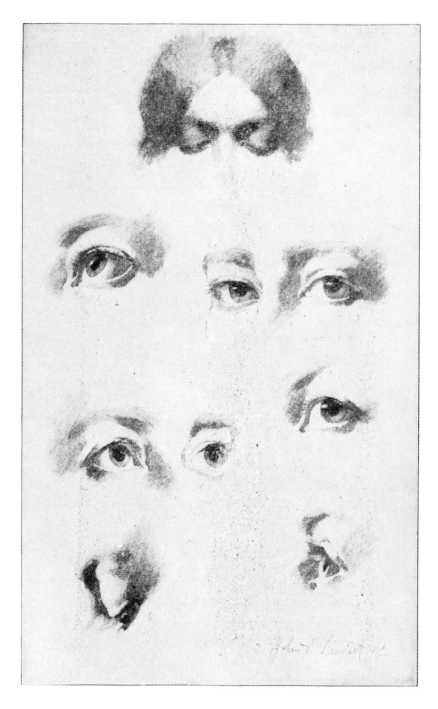

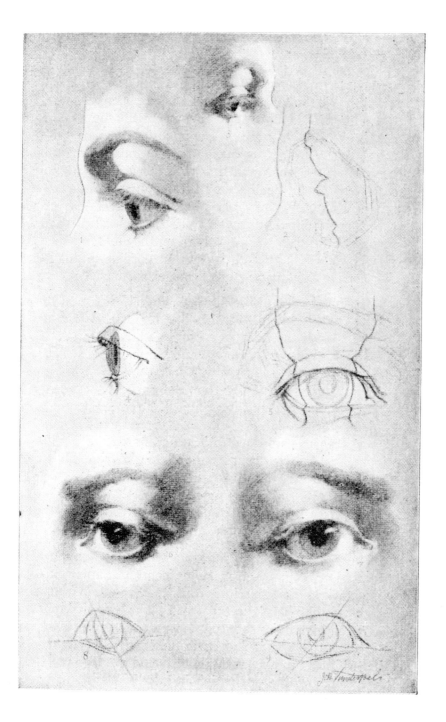

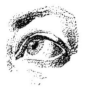

full breadth of its fold as it leaves the nearer corner of each eye is visible until it reaches the iris: here the lower line of the fold, the edge which holds the lashes, fuses with the upper line of the fold and, following the contour of the ball, descends until it reaches the opposite corner; as the breadth of the fold disappears, its thickness comes into evidence, showing plainly the inner line of the thickness of the lid in its contact wtih the ball and the slightly increased curvature caused by the greater convexity of the iris. The beauty and grace of the curvature of the lines in the eye are not exceeded by any other form in nature. In the farther eye the outer corner is not visible.

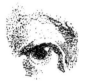

The lighting shows in similar shadows the plane of the temple and the small plane parallel in direction, the side of the nose opposite and close to the inner corner of the eye, and the mass around the outer corner of the nearer eye. This illumination gathers together the parts of each form that belong to the big planes of this part of the head, and discloses what part of the eye belongs to the front exposure of the head as against other portions that belong or are parallel to the side surface. There remain then the projecting parts, such as the raised surfaces of the lids and the eyebrow, which are in shadow or light according to their exposure to the particular illumination.

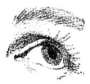

The outline of the shadow which marks the moment or angle of transition from light to dark also marks the separation from plane to plane in a large way. The plane that marks the side of the head in this region approaches the eye by means of the temple and includes the temporal portion of the orbicular muscle and that part of the lids and the corner of the eye which is parallel to it. An outline of the angle of separation of the front from

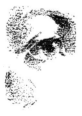

the side of the face, as indicated by the outline of the shadow, if well constructed, will repeat through the foreshortening the exact form of the opposite side of the face.

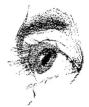

In this action of the eye, looking down, every portion of the contents of the orbital plane intensifies its definition and direction. The upper lid unfolds as it descends over the ball and delicately discloses its convex form underneath and separates itself but slightly from the orbicular muscle above.

The lower lid, beyond a slight capacity for lateral and downward contraction, plays but a slight part in recording the movements of the eye, while the upper lid responds and accommodates itself to every action and consequently is a great factor in its expression.

Though the outer corners of the eyes are slightly higher than the inner, the effect of the triangular mass of shadow under the upper lid, when the eyes look down, suggests a downward slope from the inner corner outward. In this drawing of the eyes, the inward step or slope from the temple to the corner of the eye is very noticeable.

A drawing representing the eye looking up, with the folded upper lid pressing upon the orbicular muscle in its endeavor to keep the vision clear. At the same time it represents the foreshortening due to the head being tipped back and away from the observer, which accounts for the elevation of the outer corner.

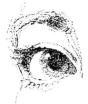

In a view of this action, the lower lid apparently flattens and in effect describes a reversed curve from corner to corner very delicately, whereas the upper lid describes the curvature of the ball with its fullness.

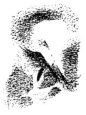

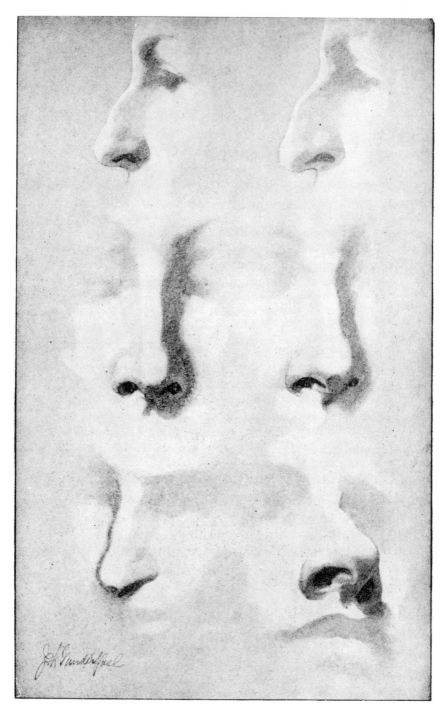

THE NOSE

◇

THE eye is suggestive of the cup-and-ball forma-
tion, a spherical form partially protuding from
its cuplike mold. The nose on the other hand stands
out well from the face with four surfaces exposed.

Considered in a large way, the nose is composed
of four subdivided surfaces. The upper surface
or breadth of the nose, containing the bridge, in-
creases in width from the point of attachment, to
the end; the two sides, beginning within the orbits,
also widen to the end and contain the wing of the
nostril; and the base, much wider at the attachment
to the face than the end, is subdivided by the middle
cartilage, the septum of the nose, flanked by the
planes containing the nostrils.

The nasal bone, which forms the origin of the
nose in its attachment to the head, fuses into the
frontal bone, by which it is overhung, by means of
the keystone shape which separates the orbits. It
extends less than half the length of the nose, the
remainder being cartilage. From its origin between
the brows the nose stands out boldly from the plane
of the middle portion of the face upon which it
rests, being deeper as well as broader at the base
or end than at the brow. This should be well con-
sidered or it will look flattened and shallow, as if
pressing into the face.

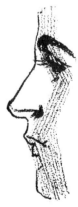

Departing from this conventionalization, the
various subdivisions of these planes should be
entered into. The upper surface containing the
bridge has its origin at the base of the keystone
between the orbits; its general surface is rounded,
though it is a little flatter and more angular at the

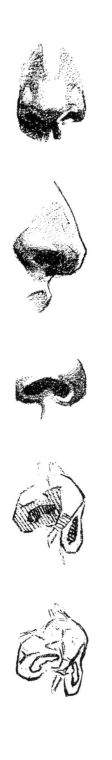

bridge than elsewhere; at the bridge too the form is raised, the height of the projection depending greatly upon the type of nose; passing the bridge the bone ceases, giving way to a cartilage of which the remainder of the nose is formed. This cartilage diminishes in width from the bridge and penetrates wedgelike the broad upper surface of the more bulbous part of the nose, the end.

Continuing, the cartilage makes a sudden turn downward, forming the upper and more conspicuous angle of the end; it now begins to diminish in width, and making another turn enclosing the breadth of the end of the nose it becomes very narrow and makes directly for the upper lip, to which it is attached with a little downward curve. On either side of this narrow cartilage or septum of the nose are the cavities of the nostrils, which in turn are flanked by the wings of the nostrils and, buttresslike, support the base of the nose.

All of these incidents or minor planes below the end belong to the under surface of the nose. The nostrils have their origin in the end of the nose, the cavity widening as it approaches the wing of the nostril, which marks its termination and completes the depth of the nose. The junction of lip with nose is about half of the depth. The septum or middle cartilage under the nose hangs so much lower than the wings of the nostrils that it subdivides the under surface into three general planes: first, the breadth of the septum, and on either side the planes that contain the cavities. The details of the under surface must be thoroughly understood or they will not remain in place; this will be particularly evidenced in a three-quarter view, in accounting for the foreshortening in the farther nostril. When the nose is lighted from above or at an angle of forty-five degrees, the de-

[28]

tails of the under surface remain undisturbed in its mass and its contents are only made known by the reflected light entering it.

The sides of the nose up above are precipitous and terminate quite abruptly near the eye, but a little lower slope outward more and fuse quite softly into the cheek. The height of the wing of the nostrils begins quite delicately a little way back along the sides of the end of the nose and terminate their dilated form sharply upon the cheek. The upper or more convex parts of the nostril belongs to the sides of the nose—while the thickness of its walls belong rather to the under surface.

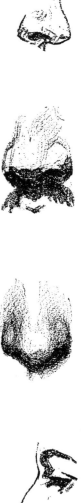

There are many types of noses and an infinite variation from each type. The character of the type of nose may be readily understood by the establishment of the relations of the three parts, namely, the relation of the bridge to the end, and of the end to the broadest part of the wing of the nostrils in its contact with the cheek. By way of illustration, draw two noses in profile, making the two alike, including the bridge, which should be fairly prominent. Now in the one case make or add a depressed end that will fall inside of or below the bridge, and then to the other an end that will rise or stand out beyond the bridge; now add to the first a wing of the nostril placed high in relation to the end and connected with it by a line that separates the under from the side surface. Do the same with the other, only place the nostril low, and note how much relationship of the parts has to do with suggesting the type and character of the nose. The parts in themselves in both drawings are about the same, the difference in the main lies in their altered relationship.

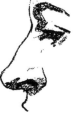

In the Greek type—the straight nose—in which

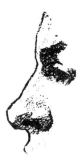

the bridge and the end are but slightly felt as deviation from the general direction, the line of direction from end to wing of the nostril is quite horizontal; in the Roman, and particularly in the hook nose, an exaggerated type, the end is depressed, the wing of the nostril high and the bridge prominent; on the contrary, in a pert nose we find a depressed bridge, the end pointing forward or upward and the nostril low.

Beware of getting the top of the nose too flat when drawing other than the profile. In the profile the form of the contour of the nose from the frontal bone to the lip is distinctly seen and readily understood, but not so in the other views; the rising and falling of the parts in connection with their increasing and decreasing widths requires the most patient study in order that all the planes may be understood and then expressed.

The two drawings below represent the nose in varied degrees of foreshortening, the rising and falling of the parts being readily discerned through it, and showing plainly the aquiline type.

This view too shows how the base of the nostrils rests upon the sides of the lip and that the junction of nose and lip is well forward of them, giving at the same time a hint of the convexity of the upper jaw and teeth, whose direction the lip follows.

The lower drawing shows the subdivision of the near side of the under surface of the nose in the light as against its opposite in shadow, proving how low the septum is in relation to the nostrils.

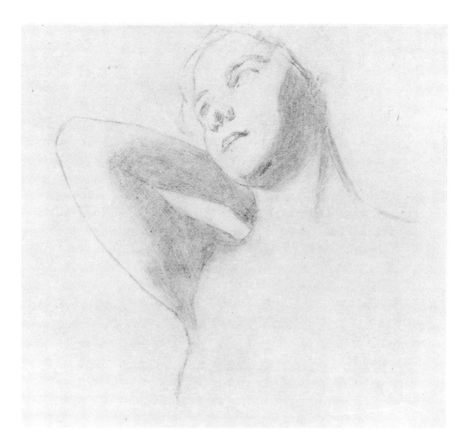

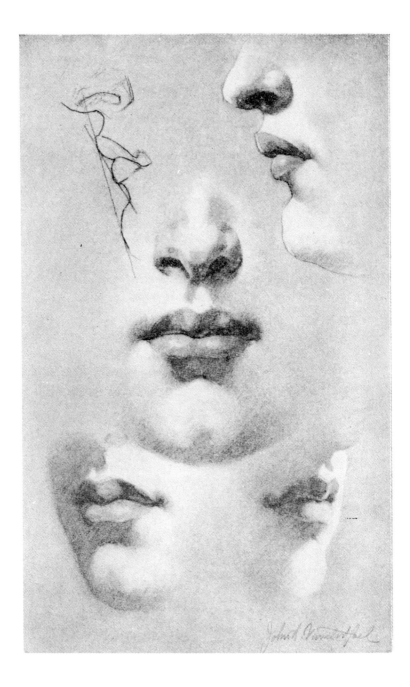

THE MOUTH AND CHIN

◇

HAVING noted the eye as a partly depressed form and the nose as a projecting one, we find the mouth peculiarly a part of its immediate environment, that is, a part of the muscular formation, though in the mass slightly raised from the plane of the face, the only attachment of the lips to the bone being at the base of the nose above, and half-way down to the chin below.

The mouth, too, like the eye, is capable of great movement, and in unison with it forms the means of the infinite variety of expression which plays in quick succession over the human countenance. Because of this mobility of expression and the softness in texture of the lips, care should be taken not to detach the parts one from the other, beyond accentuating the separation at the middle and corner.

The red or mucous surfaces of the mouth correspond to the thickness of the lips. The variety of their thickness and relative fullness is considerable, though both are thicker in the middle, tapering to the corners, but manifesting their thickness very differently.

Beginning with the front view, note first the convexity of the mass of the mouth as affected by the teeth; this means that, as the corners are farther back than the middle, the curvature of both lips in their approach to the corners involves foreshortening. Irrespective of the view or action, first establish the relation of the corners to the middle. This is exceedingly important, as it involves symmetry both in construction and action, as well as expression and character.

Though the mouth is convex in the mass and raised slightly from the general plane of the face (except at the corners, where the lips dip into a depression), the convexity is differently expressed in each lip. The mucous portion of the upper lip is divided into two equal parts or planes, of greatest width where they come together in the middle of the mouth, retreating with diminishing thickness with a downward curve to the depressed corners. The lower lip, on the other hand, contains three planes, the central one with a depression in the middle, into which the central mound of the upper lip fits, extending well on either side of the middle of the upper lip, and flanked by a minor one on each side. The planes of the upper lip are comparatively flat and angular, while those of the lower are very convex and rounded.

The space between the nose and the upper lip is concave vertically, and has its origin at the middle cartilage of the nose in the form of a depression, which widens as it descends and terminates in the delicate angle of the middle of the upper lip; the center of this angle forms the most forward part of the mouth. This angle is repeated in the contact of the upper lip with the lower immediately below this point, though the angle is more obtuse and a little flattened, showing how the upper lip clasps the lower as it overhangs it. The lower lip rolls outward, and is apt to be full and convex, in proportion to the depth of the concavity below it. This depression or length of the lower lip divides perceptibly and forms at its base the upper border of the chin which protrudes from its depth.

Through the study of the profile, which is equivalent to the vertical section, these facts are more readily understood. Note first the backward sloping plane from the nose to the base of the chin and

in it find a series of steps, the upper lip overhanging the lower and the lower lip the chin. Note the concavity in the vertical line of both lips and the convexity of their thickness or mucous portion, greater in the lower — at least more rolling — all subtly connected with adjacent parts of the face, particularly in the soft play at the corners. The separation of the thickness, or mucous portion, from the cutaneous, of the upper lip from the portion of the face above it, due to its angularity, is sharper than in the lower lip, excepting in the center of the latter at its lower border.

The thickness of the walls of the mouth, manifested variously in the changes of formation of the lips, is disclosed when the mouth is slightly opened. You will notice the thickness of the center of the upper lip; its planes are clean cut and angular. On the other hand, the fullness of the lower lip is rounded, lacking in decided angularity.

You should also pay attention to the thickness of the walls of the mouth at the corners in the front and three-quarter views. In the action of opening the mouth, as in laughter, the lips press gently against the teeth, sliding upon them as the action increases. The arch of the teeth is followed by the shape of the lips until the corners of the mouth are reached, the corners sharing the direction of the plane of the cheeks, and when the corners are pulled back, in the act of smiling, a little space is left between the corners and the teeth, marked by deep shadows.

It will be observed that in the action referred to, in the front view, the detail of the line that marks the base of the upper lip is horizontal, while the general form of the upper line of the lower lip against the teeth appears concave, approaching the upper lip at an acute angle at the ends, but melting

into it with a graceful turn at the corners. The lower lip, too, flattens out considerably and becomes more angular. This may be readily seen in the decrease of the concavity below the under lip, this depression becoming much less marked.

The angularity of the horizontal planes of the lips is made the more evident in the smiling mouth (three-quarter view, slightly foreshortened), showing the two planes in the thickness of the upper lip and and the three in the lower, the large middle surface being pressed against the teeth.

The opening of the mouth is due to the action of the lower jaw, and though the lower lip may be slightly contracted, the teeth show but little except in decided laughter. On the other hand, the upper jaw being stationary, the teeth show below the upper lip, and the least expression that pulls back the corners of the mouth, contracting the upper lip, shows them more fully.

The mass of the chin envelopes the front plane of the lower jaw and is angular or rounded accordingly as the sitter is youthful and plump or old and attenuated.

Its form, as seen in the profile, depends greatly upon the development of character and racial type. It may protrude beyond the lower lip with considerable decision or fall back of it in a retiring manner. In the more normal type it falls about underneath the lower lip.

The lower border of the chin is straight across, containing a slight depression in the center. The lateral borders are quite round and stand away slightly from the walls of the jaw; the upper surface, which marks the depth of the chin as it protrudes from the face, is convex and enters the center of the length of the lower lip.

The breadth of the chin becomes the base of an elongated triangle, made by two lines descending from the septum of the nose at its apex. The lateral borders of this triangle pass through or touch upon the borders of the groove above the upper lip, continuing through the angles at its mucous borders and finally through the fullest part of the lower lip to the chin.

In the mouth of the child it will be noticed that in the pressure between the cheeks the middle of the upper lip is pushed forward greatly, the sides of the lip being at quite an angle to one another; as the pressure is removed with increase of years, the angle diminishes and the mouth becomes flatter and wider. The lower lip, however, falls back snugly between the cheeks, so that in the profile of a child the upper lip and chin only are visible. In old age, the lack of the teeth throws the lower jaw forward to such an extent that though the lower lip falls back locally as well as the upper lip, it is apt to protrude beyond the upper lip because of the projecting jaw.

In a larger way, as well as in detail, we find the forms about the mouth quite opposite to one another in the extremes of age; in the child we find the mouth contained in a vertical groove between the rounded cheeks, into which the lower lip sinks, and from which the upper lip protrudes; in old age, the teeth and fullness of cheeks have fallen away so that the groove now is horizontal along the line of the lips, into which the upper lip dips and the lower protrudes.

The length of the upper lip (meaning the space between nose and mouth) at its origin should leave the septum of the nose with a slight curve, not a sharp angle; its vertical line in the center is con-

cave, and at the separation of the mucous part or thickness from its length we find a decided angle both vertically and horizontally; this marks the most forward part of the mouth.

The "length" of the upper lip is used in this discussion for convenience to indicate the central space from the nose to the mouth, the region referred to when we say "a man has a long upper lip."

The middle portion of the length of the upper lip is parallel to the front plane of the face and is marked by a delicate groove which widens in its descent to the thickness where it terminates with a projecting obtuse angle forming the apex of the upper lip.

It is a common error to draw the line of the upper border of the red part of the lips, in the profile, direct to the apex mentioned. In the profile, the two borders of the groove in the length of the upper lip merge into one and find a continuation in the merged lines of the projecting angle forming the apex of the lip, so that in the profile the length of the upper lip extends to the apex and the upper border of the thickness of the wing of the lip enters the length above the apex, by a space equal in height to the depth of the projecting angle.

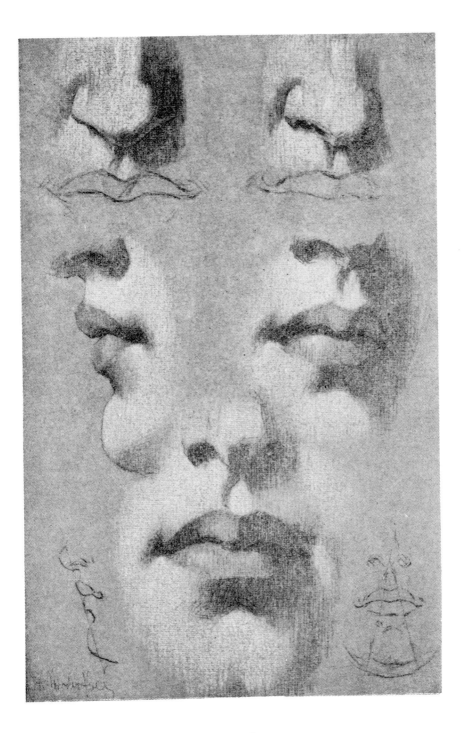

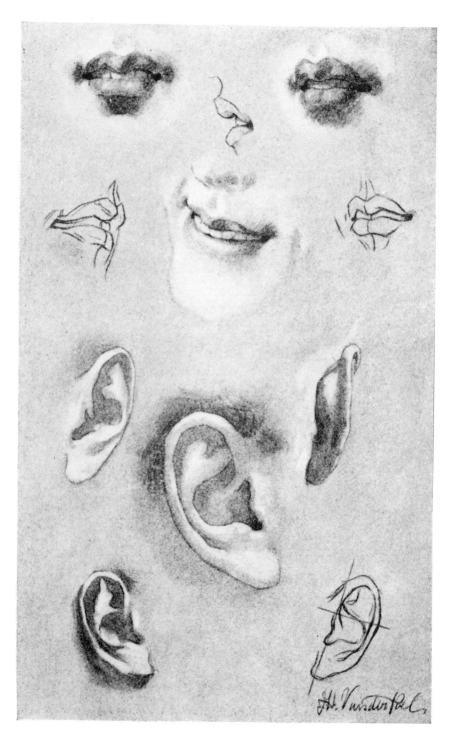

THE EAR

◇

THE ear, being entirely cartilaginous, might be described as a bowl with elongated brim along its upper and lower extremities, with the base of the bowl and one side fastened to the side of the head, leaving the outer rim and the extremities free and giving a slight outer direction to the ear in its angle to the side of the face. It has it's origin just back of the articulation of the lower jaw, about in the middle of the head, as seen in the profile, separating the face from the back of the head, and running parallel with the upper angle of the jaw. This means that the lower part of the ear is nearer the face than the upper.

At the location of the ear the jaw stands away a step from the back of the head, and this interval is filled by the bowl of the ear, giving the inner rim contact with the head and leaving the outer free.

On the face side of the ear, the bowl or shell is protected by a small raised form or flap which shields the orifice, and is connected below to the cartilage that forms the immediate rim around the bowl. The cartilage that surrounds the bowl and by which means it is attached to the head is the most firm portion of the ear, while the lobe is the softest.

In the front view the ears slope inward from above and conform to the planes that mark the decreasing width of the head from the cheekbones down.

From within the bowl and behind the little flap rises the external cartilage or outer rim of the ear.

[41]

It continues upward, completing the length, turns backward, and forming the upper border descends to the greatest breadth, which is about a third of the way down, or about opposite the upper rim of the bowl; continuing its descent, it approaches the front border somewhat, to the level of the lower rim of the bowl, representing another third; in its detour this outer rim begins with a fold well turned upon itself, but at the approach to the greatest width of the ear this depth diminishes, and opposite the lower part of the bowl the rim is but separated by a groove, which is entirely dissipated as the rim enters the soft and somewhat flattened lobe.

The ear is apt to be neglected by artists, probably first, because of its retired location; second, because it is often hidden by the hair and headdress, and finally, because of its taking no part in the expression or action of the head. The draftsman, however, is readily betrayed through his neglect and it is in just such forms as the ear that he shows his skill and knowledge, and the beauty and delicacy as well as strength of its intricate forms are worthy of his most careful attention.

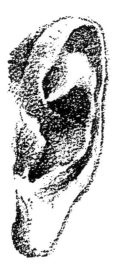
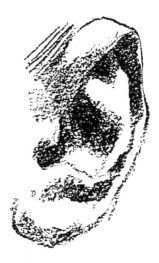

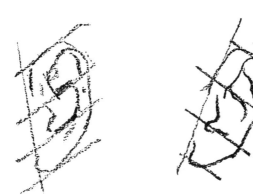

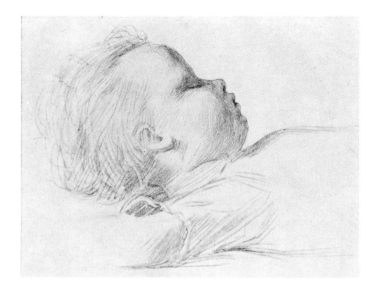

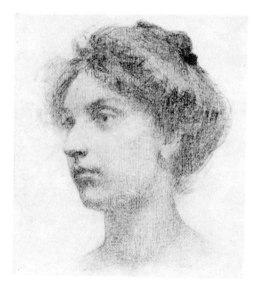

THE HEAD

❖

IN the head of the lower animal there are certain structural characteristics that obtain equally in the human head, and which, once appreciated, enable the student the more readily to understand the relationship of the planes that bound it. We find the same skeleton or bony structure upon which to build, the cranium or rounded receptacle enclosing the brain, the orbits, the cheek bones, the nasal bone and the jaw. The great difference is not found in kind but in degree. However, irrespective of the difference there may be between one animal and another, the difference between them collectively and the human being is so great, the gap so wide, that superficially considered, all trace of the lower animal is lost.

There are two radical structural differences to be mentioned: first, the relative position and the proportion of the lower to the upper part of the skull, and second, the relative position of the head to the body. The head of the animal is carried in a nearly horizontal position, whereas man carries it in a vertical position.

Taking the eye and ear as a median line from which to depart, their relative position being the same in man and animal, it will be noticed that above the line, the brain development in man makes for an upward enlargement of the top of the skull and a forward pressure of the frontal bone, placing the frontal bone at right angles, or nearly so, to the top of the head. Below the median line it will be observed that the large muzzle of the animal projects strongly from the skull with the nose well

[45]

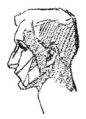

flattened upon it, placing the muzzle at right angles to the jaw, the lower jaw and embryo chin extending proportionately from the throat.

In proportion, then, the upper part of the human head is large above the median line and the head of the animal large below the median line.

The change in proportions brings with it a change in the relative position of the parts. A line drawn through the length of the animals head runs diagonally through the median line, whereas in man it crosses it nearly at right angles; as the brain develops it rises vertically, and with its development the lower part of the head retires and falls directly under it.

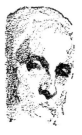

In the face of man, the differences are manifested in the well-nigh vertical and overhanging frontal bone, the chiseled, projecting nose, and the highly developed chin; in the animal these same forms are reduced to the low sloping head, the flat, fused nose and rudimentary chin.

It is in the middle and lower part of the human head that traces of the animal nature manifest themselves, even in the highly developed man. The plane upon which the nose rests partakes of the projecting muzzle in the animal and, as in the animal, the lower part of the face has a tendency to retire, but this tendency is modified by the developed and projecting chin.

Having studied the component parts of the head in the shape of the features, and looked into the comparative form of the head in the animal and man, the next step will be the study of the construction of the head as a whole, through an analysis of the larger planes, as they bound and give it substance.

A pupil must learn early in the study of drawing to appreciate mentally all the planes that encompass the head, though to the physical eye from a given point of view only certain ones may be visible. This consciousness and understanding of the planes will enable the student the more readily to approach and comprehend the three essentials that characterize a strong drawing: first, the carriage of the head, or its action; second, its construction; third, the character and personality of the sitter. With thorough appreciation of the three requirements, accompanied by a simplicity of expression through a practiced hand, the student is well on the way to draftsmanship.

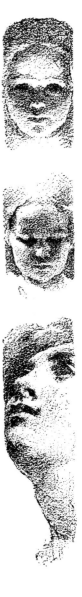

The head is composed of six planes, five of which are visible, while the sixth (the under surface) is mainly hidden by the entrance of neck and throat, leaving the under surface of the jaw the only portion of this plane intact. The other surfaces comprise the face or front plane, the back, the top of the head, and the two sides; the latter notably are the only ones that are alike.

Fully to realize the existence of these planes, imagine a cube with all its corners and edges rounded. This will keep the sense of a solid and its planes before the mind's eye. Further, take up a skull, and with a bit of chalk mark the detachment of these surfaces one from the other, and though at first in the living model the subtle curvature and fusing of one plane into the other will be puzzling, they can in this manner be placed, so that no matter what the students ocular point of view may be when drawing from the model he can not miss them.

When seen in profile the lines that define the proportions of the head, breadth to length, should first be placed; the breadth of the top first; next

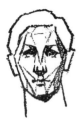

a long line for the front or face; another along the back and a fourth placed quite diagonally from base of skull along the jaw to end of chin. This diagram, somewhat of a diamond shape, though it gives the angles of the planes, pretends to do no more than to give the general proportions and location of the big planes. Each plane may now be subdivided so as to locate crown of head in the upper surface; the fullness of the back of the head as it projects beyond the neck; in the face separating brow or frontal bone from lower half of head; and in the under surface introducing the neck, which is placed well back of the center of the skull.

It will be observed now that the greatest breadth is across the brow to the fullest part of the back of head. This division marks the separation of the upper from the lower part of the head, each portion in its ascent and descent decreasing in width to its termination. The upper portion is shorter in the front of the head, while the lower part is shorter in the back.

In order that the planes and their boundaries may be more readily understood in these constructive drawings of the human head and figure, the effect of light and shade has been very simply used, with the purpose of giving the third dimension through the marked transition of the surfaces under the strong illumination.

For the purpose of study the student should illumine the head with a narrow and single source of light. By pulling down the shades of other windows than the one to be used and closing the lower half of that, a stream of light enters the room at an angle of about forty-five degrees. Now if we place the sitter at such an angle to the light as will throw the side and back of the head in

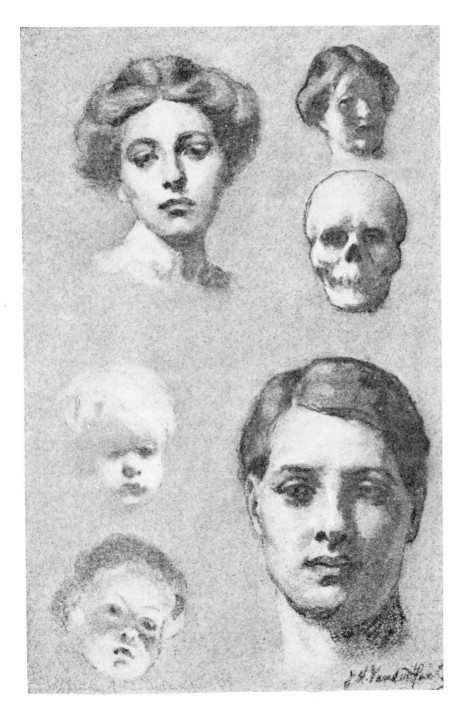

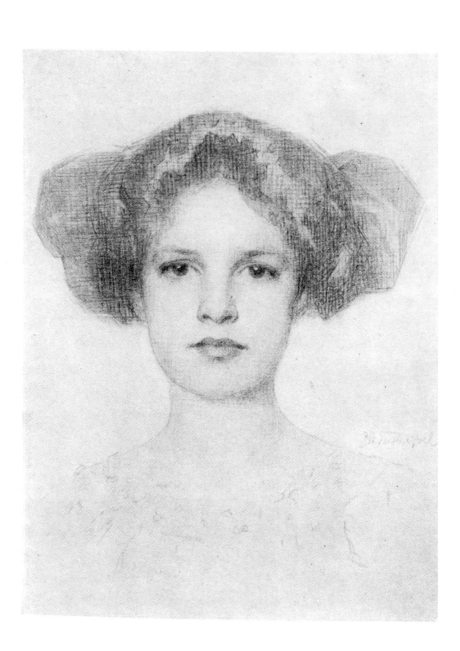

shadow, the source of light being above the level of the sitter, the top of the head and front of the face will be in the light, and all overhanging and projecting parts will be in shadow with the side and back. Great care should be taken to turn the head so as to locate through the edge of shadow the points or ridge of separation of side from front. A cube similarly placed will show the upper and one side surface the side equivalent to the face, in the light and the side nearest the student in shadow.

With such simple illumination, and the shadows kept quiet through lack of diffused and reflected light, the relative location of planes and their demarcation become luminous to the students mind as well as eye.

The two sides of the head are symmetrical structurally. This is theoretically true of the details as well as the larger forms; but in actual character there are many deviations from the regular; the eyebrows are not exactly alike, nor are the corners of the mouth; one may be higher than the other or deeper, there may be discrepancies in many ways; but one should reflect before recognizing these slight differences too early, for what proves to be but a slight deviation from the regular may become a deformity. In principle the two sides of the head are in perfect symmetry. Any variation that relates to the character of a head should be so carefully rendered as not to destroy the balance of the parts.

In the front view, as in the profile, the greatest width of the head is found just above the ears; it is the location of the greatest width at this point that suggests the egg shape as a conventionalized form for the head.

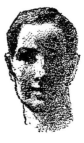

In locating the planes in the front view, find

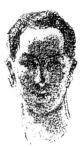

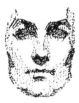

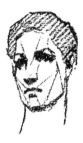

first the top of the head terminating with the fore-head, marking the upper boundary of the face; next, the sides of the head enclosing the forehead by means of the temples; and third, the lower part of the face; next, the sides of the cheeks to the chin. Below, forming the lower border of the face, is the under surface of the jaw. Here, too, the greatest width is above the center, resulting in the same oval form for the face as the head.

Conceive in the drawing of the face, first, the vertical plane of the forehead bounded at its lateral borders by the planes of the temples, which depart from one another as far as the cheekbones, locating the widest part of the face; next, a plane combining the eye-sockets sloping inward at an obtuse angle with the forehead; below this find the largest plane of the face, the plane of the cheeks, bisected by the nose. It is bounded above by the eye-sockets, and extends slightly beyond them at the base of the temples, forming the greatest width of the face at the cheek-bones. As it descends, the plane decreases more rapidly in width than the face and terminates like an inverted triangle at the apex of the upper lip. The two sides of this triangular plane are bordered by the sides of the face, from the cheek-bones down, whose planes slightly approach one another as they descend from the cheek-bones, marking the tapering of the face from its greatest width to the jaws.

The chiseling of these planes is more manifest in the thin face than the fleshy one, and it is the knowledge of them that has such significant value to the painter, as the planes in the face denote more intrinsically the character of the head than the mere features.

The drawing of a three-quarter view means the foreshortening of the face between the sides of the

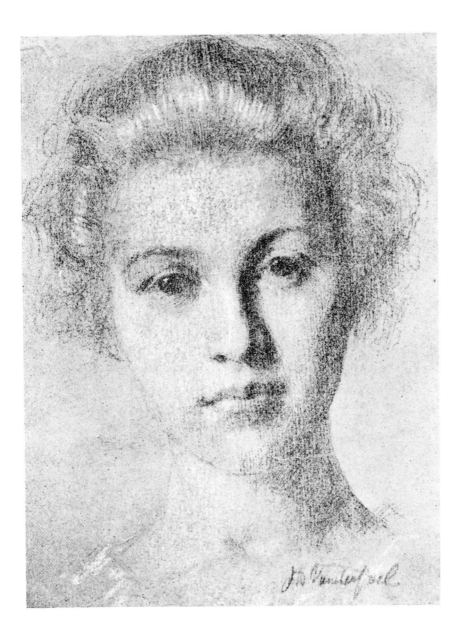

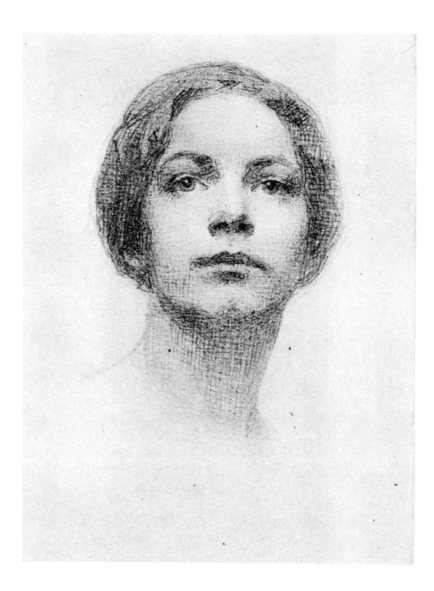

head and the nearer side between the back of head and the face. In such foreshortening the farther half of the face becomes narrow in ratio as the nearer half of the head widens, and the ratio must be kept with exactness or the farther half of the face will look out of proportion, as the tendency is to make it too broad.

When the head tips back or leans forward and is seen three-quarter view, the foreshortening becomes double and therefore greatly complicates the relative position of the planes. When the head leans forward, the amount seen of the top of the head is greatly increased, as if we were looking down upon it. The ears, which are on a line with the base of the nose and eyebrows, are now found to be too high, the inner end of the eyebrows are placed low in relation to the outer, the outer corners of the eyes are higher than the inner, the wings of the nostrils are higher than the end of the nose, and the corners of the mouth higher than the middle; but when the head leans back, all these relationships are reversed. We see none of the top of the head but we look into the under surface of the jaw and chin, the under surfaces of the lips and nose, and the overhanging surface of the orbits. All these are the obvious, though minor manifestations of foreshortening. The large planes in which the features are contained, or of which they are a part, should receive the first consideration, for the features, however important in themselves in the early stages of the development of a drawing, should be subordinated to the larger planes of which they are but a part.

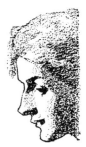

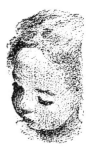

In the head leaning forward the forehead is but slightly affected, the orbits, however, in proportion as they are deep, become shallow in the foreshortening; on the contrary, the plane of the

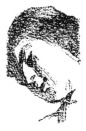

central portion of the face upon which the nose rests is seen to the full, in turn the lower part of the face from the mouth down becomes apparently much shorter. When the head tips back, these relations become reversed.

The drawing of a head well foreshortened is indeed a test of an artist's structural sense. Such an achievement bespeaks a familiarity with its planes irrespective of position or point of view.

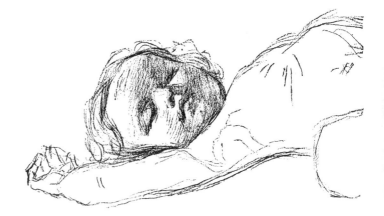

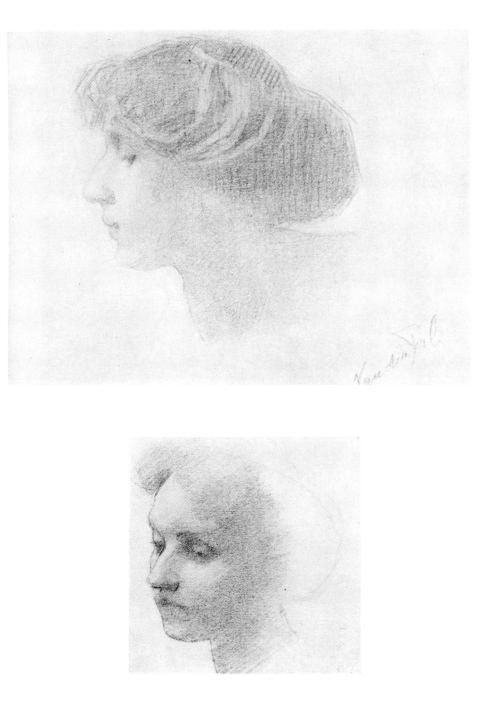

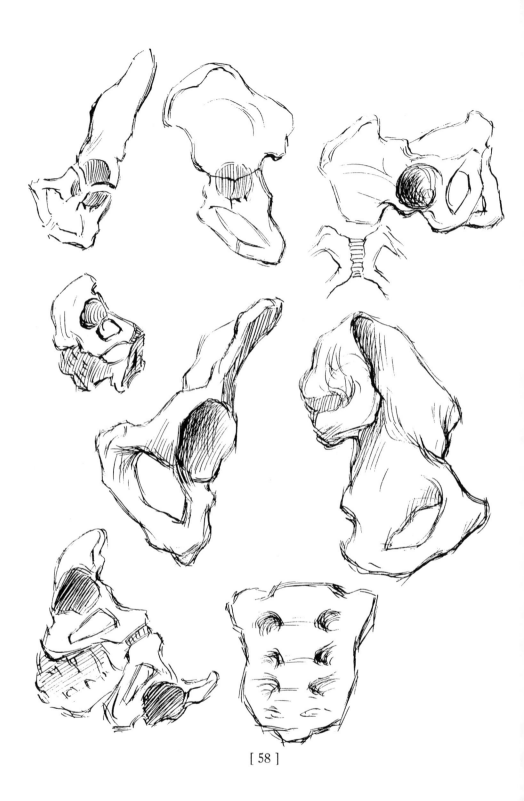

THE BONY STRUCTURE OF THE TRUNK

◇

THE thigh-bones or femurs with projecting heads, support a backward-sloping, bowl-like platform (the pelvis) composed of the two iliac bones, between which, firmly wedged and keystone in shape, rests the sacrum, so fused with the pelvis as to make a common mass.

While the pelvis leans forward, the sacrum receives the weight of the thorax through the spinal column, and is located immediately above the head of the femur to which it is transmitted.

The sacrum terminates with the coccyx, which, with the sacrum, determines the outward slope of the lower part of the back, this slope deviating more from the vertical in the female than the male.

The spinal column, including the sacrum and coccyx, which are in reality fused vertebræ, describes a double reverse curve with a forward and backward movement. It tapers delicately from the sacrum up and is made of disks which permit of lateral and forward and backward movements according to location. The lumbar vertebræ in the region of the small of the back permit of lateral and backward movement; on the other hand, the dorsal vertebræ, to which the ribs are attached, permit of forward movement, but partake little in the lateral, and do not enter at all into a backward action; the cervical vertebræ enter into any of these actions, being the most free in construction of all.

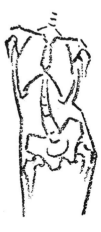

The spinal column terminates above the atlas bone, the mechanism of which permits of a con-

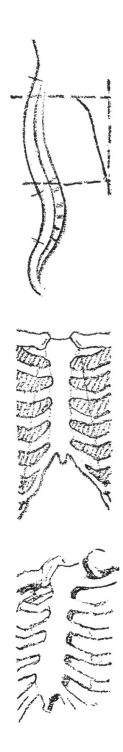

siderable degree of rotation of the head, which rests upon it.

The ribs are attached to the spinal column in the dorsal region. As they leave the spine their direction is somewhat downward and backward, causing the body of the spine to appear embedded deeply between them, the downward direction increasing in the lower ribs, and the length of the backward direction being greater at the bottom of the thorax than at the top, causing the groove of which the spine is the center to grow wider as it descends. The ribs now make a forward sweep at the sides and rise by means of a cartilage to the sternum or breast-bone, to which the seven upper ribs are attached; three, called false ribs, are attached cartilaginously to one another and finally, by means of the sixth rib, to the sternum; while the two lowest ribs, diminishing in length as they descend, are free from any connection but the spine and are called floating ribs.

The sternum or breast-bone runs parallel to the lower dorsal vertebræ, beginning at the level of the second dorsal vertebræ. It has a broad head upon whose sides the clavicles rest and a blade to which the ribs are attached.

The formation of the false ribs in their attachment to one another and their rise to the sternum produces the thoracic arch, which marks the boundary line between the thorax and the abdominal cavity, separating the upper from the central mass of the body, though by means of the arch the masses pass one another and interlace.

The form of the mass of ribs is slightly conical. At its greatest width, about the seventh rib down, it is a trifle narrower than the measurement across the heads of the femurs or hips, showing that the

more solid part of the body tapers upward, the superficial taper from above down in the living figure being due to the added mass of the shoulder on either side of the upper part of the thorax.

The clavicle, on each side describing a reverse curve from the sternum outward, produces the shape of the convexity of the forward surface of the thorax, and reversing its curvature sends out its extremity to meet the flattened acromion process of the scapula, which comes from behind.

The scapula is a flat, triangular bone, exhibiting a slight convexity, very thin, but strengthened by its projecting spine. Its only bony attachment to the skeleton is by means of the clavicles hinge upon the head of the sternum, so that the whole mass of the shoulders may be raised, giving the appearance of the neck being depressed between them. Just below the juncture of clavicle and scapula, and at the upper end of the outer border of the latter, is the cuplike socket which makes the receptacle for the head of the humerus or upper bone of the arm.

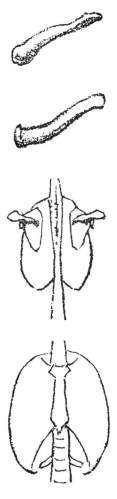

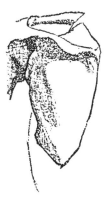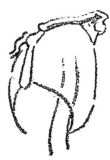

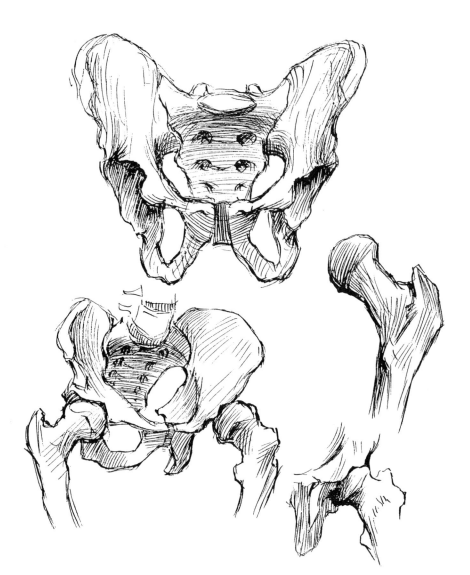

THE STUDY OF THE TRUNK

◇

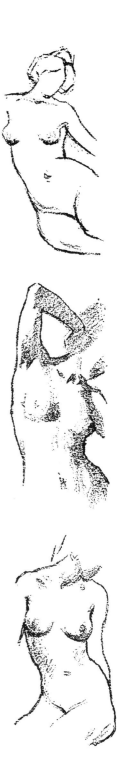

BEFORE entering upon the study of the component parts of the body, it is of the highest importance that the large planes of which the minor forms are a part should be thoroughly understood. A mental grasp of them in the large is essential to strong draftsmanship.

The accompanying plates should be an aid and should facilitate the student's conception of the great planes of the body, representing as they do the elimination of all minor forms, and disclosing, in so doing, the simple elemental plans which encompass the body.

These drawings are but diagrams, conventionalizing the human form to the last analysis, and should be treated as such, for their object is only to enable the student readily to locate the angles of transition from plane to plane.

The body or trunk may be divided into three vertical masses, two of which are alike in structure. First, the shoulders, thorax, small of the back and abdominal region, form between them a shape like an elongated, irregular pyramid or wedge, the shoulders forming the base and the lowest point of the abdomen the apex. Second, flanking this wedge on either side and rising from the greatest width of the thigh as a base, the mass of the hips and pelvis, buttresslike, support the lower part of the wedge or abdominal region, to the height of the waist.

The wedging in of the lower part of the body between the buttresslike hips forms the most nota-

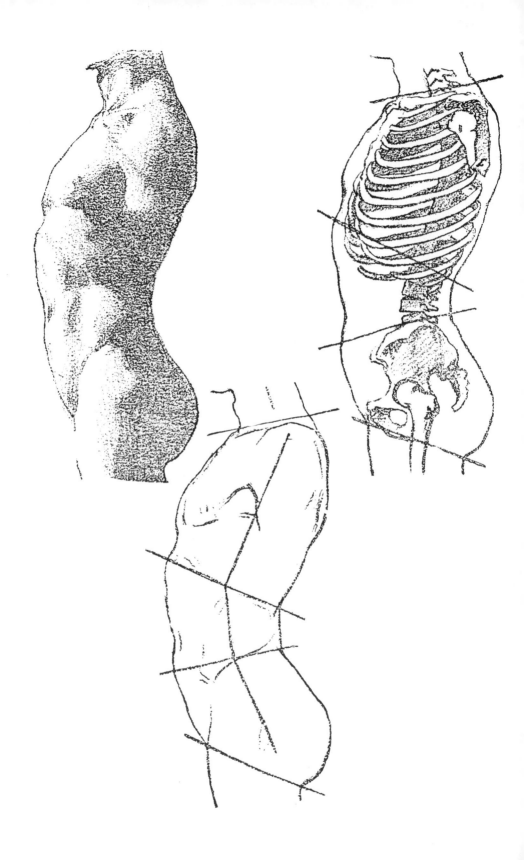

ble instance of the interrelation of parts which is so universal in the human organism. From this region all the important actions that the human body is capable of emanate, for the hip and pelvis form the point of transmission, from lower to upper part of the body, of all the power that controls great movements.

To understand the human form it must be drawn from many points of view. This will enable the student to see form as the sculptor does, so that he will see around his view, and conceive the idea of solidity without a sacrifice of silhouette.

In silhouette the back and front views are alike, as are the right and left profiles, but in solid representation, though the profiles are alike, the front and back view are in many ways materially unlike; for the front of the body, from the head of the sternum to the base of the abdomen, is convex, while the back (longer than the front) is comprised of a double reverse curve, which is most concave in the small of the back, opposite the fullest part of the front, and convex at the shoulder-blade above, opposite the sternum, and again convex at the base of the back, opposite the lowest part of the abdomen.

Irrespective of the point of view and of action, the difference between front and back and the basic form of wedge and buttress may readily be traced in the human trunk.

In the profile or vertical section the body may be divided into three horizontal sections, the upper containing the cage of ribs, the central containing the abdominal mass, located between the false ribs and the crest of the pelvis, and the lower containing the pelvis, the lower portion of the abdomen and the extremity of the back.

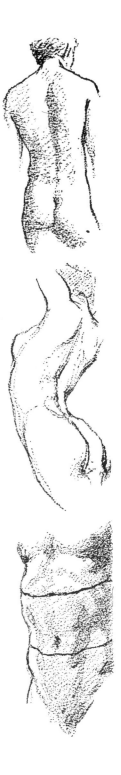

[65]

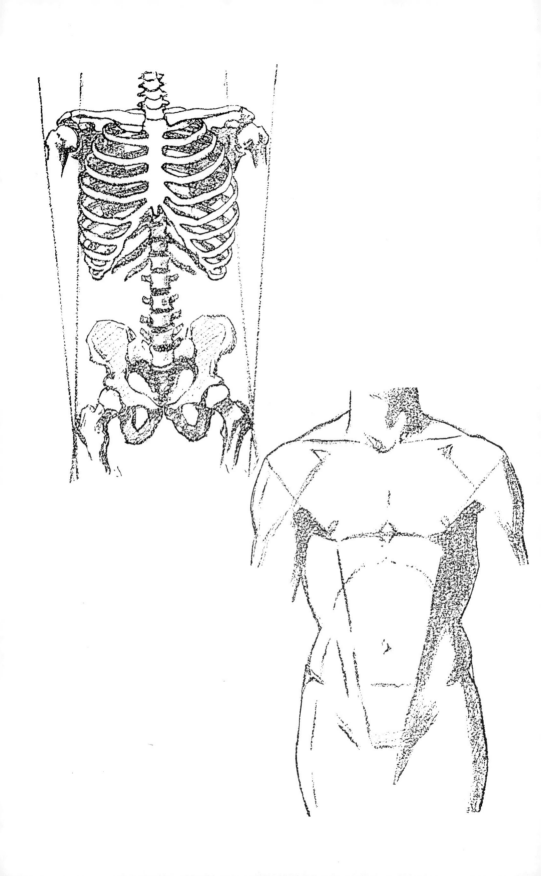

The upper and lower masses are remarkable for their bony character. The upper, like a cage made of the ribs, the sternum, the clavicles and the scapula, all supported by the spine, encloses the vital organs. The muscles that clothe this form are greatly affected by this bony cage in the production of the planes. The only bony form in the central mass is the column of vertebrae in the small of the back. In the lower mass the bones are heavy and deep-seated instead of external, only coming to the surface at crest of the pelvis, the coccyx, and the head of the femur or hip bone; aside from the crest of the pelvis and head of the femur, which form the two bony points in the buttresslike form on each side, the bones affect the external form less than above. The muscles producing the external planes come from a deeper origin in consequence, and are less affected externally by the bones within.

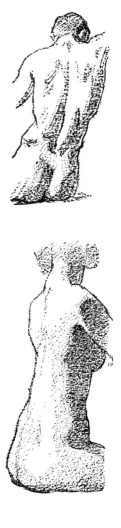

In establishing this division of three masses in the body we must fix lines or planes to locate their demarcation.

The upper mass is bounded above by the line at the base of the neck marking the thickness of this region, from the pit of the throat to the vertebral prominence. This plane slopes upward from front to back. In the back the form is bounded from above down by the outward slope of the trapezius, the shoulder-blade, and the latissimus dorsi, as far as the upper angle of the small of the back. In the front is found the plane of the chest, made by the pectoral muscles and the cartilaginous form of the false ribs, which in the errect figure extends beyond the chest, forming the highest projection along the profile of the front of the figure. The base, then, of this upper mass extends diagonally downward along the arch of the false ribs to the upper angle of the small of the back. It will be

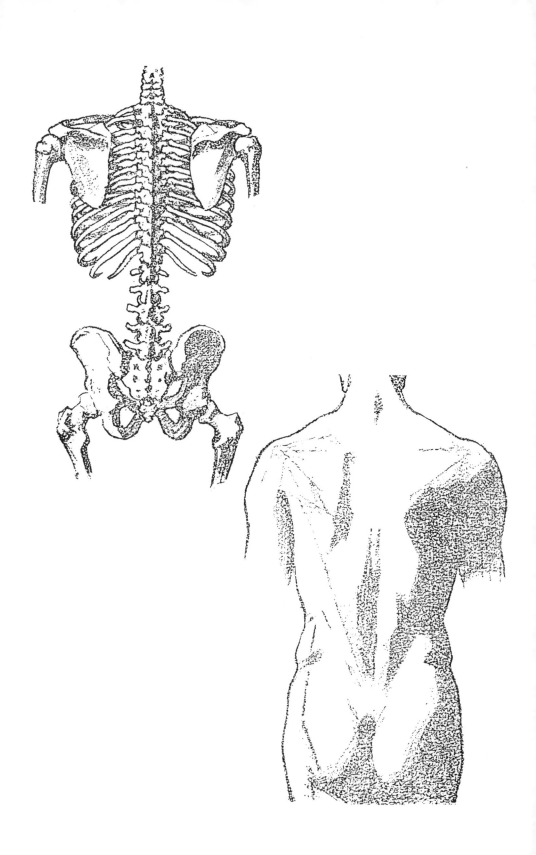

noted that the direction of this mass from the diagonal line of the false ribs up is controlled by the backward slope of the chest in front, and its parallel, the latissimus, in the back, so that a line drawn through the center of the mass, from the false ribs upward, passing through the vertebral prominence, slopes backward decidedly, parallel to the dorsal vertebrae.

The central mass, wedged between the upper and lower, is fleshy except for the spine, and only the processes of the vertebrae are visible in the groove along its course in the small of the back. The upper boundary of this mass is marked by the diagonal line of the false ribs; the front boundary by the abdominal wall (which slopes inward slightly) beginning with the highest point of the false ribs and terminating at a point a little below the navel, where the abdominal wall takes a deeper inward turn; and the lower boundary is marked by a line drawn from the angle made by the upper and lower parts of the abdomen diagonally upward and backward through the crest of the ilium to the angle at the base of the small of the back. This line, in accord with the crest of the ilium, is opposite in direction to the line of the false ribs. The small of the back marks the boundary in the back, and being nearly parallel to the abdominal wall in front, with it controls the direction of this mass. A line drawn through its axis or center discloses a slight forward leaning.

The lower mass is bounded above by the pelvic slope; in front by the lower part of the abdomen, which slopes inward between the thighs; along the back by the under portion of the buttock as far as its attachment to the thigh. This attachment is so much lower than the point where the abdomen goes between the thighs that the line marking the base

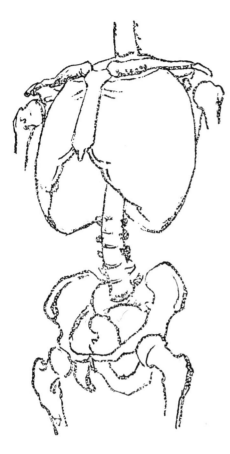

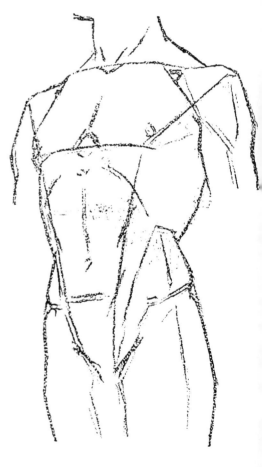

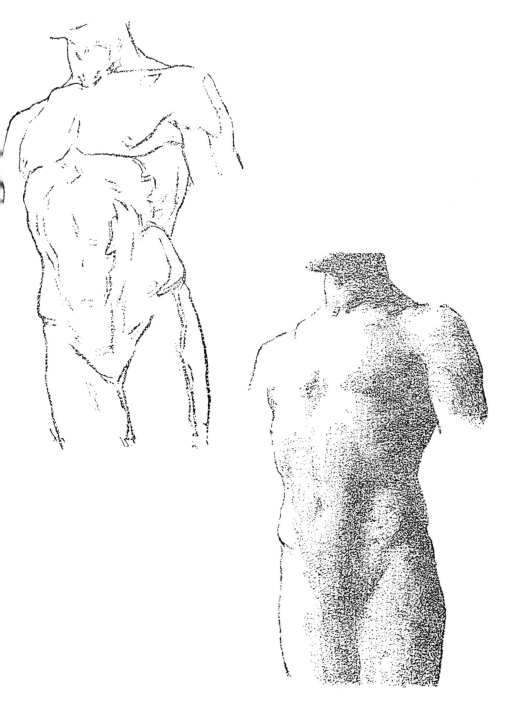

of the body slopes in the opposite direction to that which marks the attachment of neck to body. The direction of the lower mass being controlled by the position of the gluteus maximus muscle, the lower part of the back, and its parallel, the lower part of the abdomen—slopes decidedly backward and downward and is opposed in position and in the direction of all its boundaries to the upper mass.

The trunk should be studied and drawn at least from five points of view; the profile, the front and back views, and two three-quarter views, one of three-quarter front and the other of three-quarter back view.

As remarked above, the front and back views, though different in relief, are alike in silhouette, and this is equally true of the three-quarter views of front and back, that is, on condition that they are seen from the same elevation and angle.

That the third dimension, the dimension of solidity, becomes an important factor, may readily be understood and made interesting by observing that two drawings may be alike in the silhouette, the first and second dimensions, but in the nature of their relief or manifestation of the third dimension may be entirely different.

Having studied the vertical section of the profile of the trunk, giving the relation of three divisions that comprise it, and before going into the formation of its projecting planes, the front and back views should be considered to that end.

The irregular and inverted pyramid that represents the conventionalized form of the body contains the grand planes of which the body is composed. In the front of the body is found the great plane of the chest, with its outward slope tapering as it descends from the great width across the

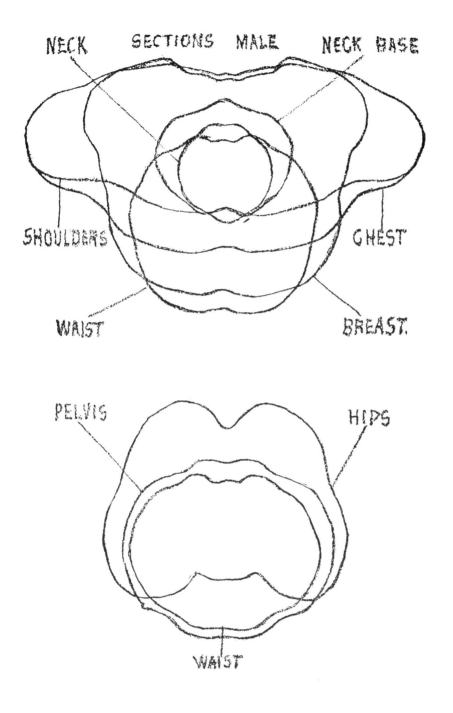

NECK SECTIONS MALE NECK BASE

SHOULDERS CHEST

WAIST BREAST.

PELVIS HIPS

WAIST

clavicles at the shoulders to its base across the nipples, separating the chest nearly at right angles from the side of the body. Immediately below is the great abdominal plane, sloping inward a little and tapering slightly as it descends to the angle just below the navel, which separates it from the lower abdominal plane forming the apex of the pyramid. The planes of the sides are at a slight obtuse angle to the front, making the back somewhat wider than the front. Thus the wedge in the back is wider and shorter in appearance than the front, because it penetrates in the lower part of the body at a higher elevation than in front.

In the back the plane of the shoulder-blades is nearly perpendicular and placed opposite the chest, though not so long. Immediately below, this vertical plane of the back slopes in rapidly, and tapering, is inserted just below the small of the back between the subdivisions of the buttock. The plane of the buttock slopes outward, diminishing in width to the base, and turns inward abruptly to the back of the thighs. The flat planes of the sides of the body first widen to the greatest width from the nipples to the shoulder-blades, and then diminish in width in their inward slope to the waist.

Against the lower termination of the sides and a little back of the center of the waist, the buttress form of the pelvis and hip asserts itself, becoming wider and deeper in its outward and backward slope until it reaches the diagonal slope of the crest of the pelvis, from which it descends in greater width and thickness to the hip at the side, the thigh in front, and the fullness of the buttock behind.

SECTIONS FEMALE

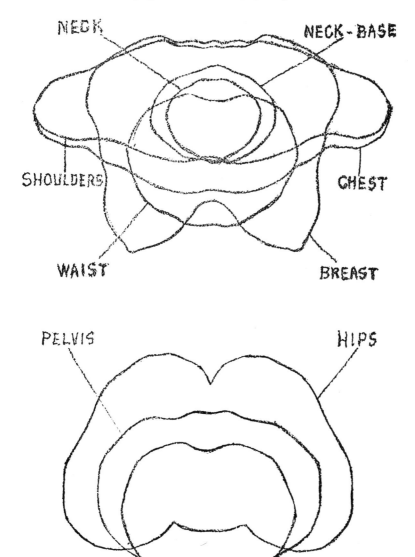

NECK

NECK-BASE

SHOULDERS

CHEST

WAIST

BREAST

PELVIS

HIPS

WAIST

THE TRUNK, FRONT AND BACK

◇

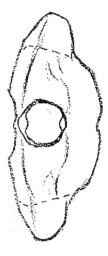

THE neck issues from the upper plane of the body comprised within the shoulder girdle, the shoulder girdle being composed of the head of the sternum or breast-bone, the clavicles or collar-bones, and the scapulas or shoulder-blades. A horizontal section of this region embracing all the minor forms becomes an irregular oval. The greatest variation in the back lies in the depression between the shoulder-blades containing the backbone, and in the front in the falling back, steplike, of the front plane of the shoulders from the breadth of the chest.

Descending from the shoulder girdle to the level of the arm-pit a great change takes place in the nature of the horizontal section or shape of the mass.

The cagelike form of the ribs becomes more square as it descends, and this angularity is greatly increased by the cushionlike form of the pectoral muscles in front and the latissimus dorsi in the back, so that the section becomes most nearly square in the thorax in the region just above the nipples, being somewhat wider in the back than across the chest. This should be distinctly kept in mind, for it causes the sides of the body to face forward slightly.

The pectoral muscles have their origin along the length of the sternum or breast-bone. Increasing in thickness until they reach a line from the nipple to the arm-pit, they become like a heavy cushion. In proportion as the pectorals are thick and marked, so is the chest apt to be square in horizontal section.

[77]

The line from the nipple to the arm-pit forms the angle separating the chest from the side of the body. This line slopes back diagonally as it rises to the front plane of the shoulder. The plane of the side of the thorax parts from the plane of the chest at a slightly obtuse angle. It contains the arm-pit, formed by the thickness of the pectoral in front and by the raised latissimus dorsi behind.

The latissimus dorsi, a great triangular sheet of muscle, rises from the lower central part of the spine and runs diagonally to the arm-pit, resting with its base on the back and its apex attached near the upper end of the upper bone of the arm near the side of the body. The horizontal section of the back, on a line with the nipples, is not unlike the back of the shoulder girdle, except that the depression between the shoulder blades is deeper. The region of the chest is the most angular section or plane in the body, and the angularity becomes emphasized when the lungs are strongly inflated.

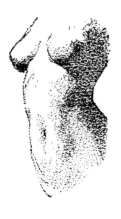

The body of the erect female figure shows the course of the angle that separates the front from the side planes, as it travels its length down the body. Beginning with the apex o the shoulders, imagine lines descending to the nipples; these with lines from shoulder to shoulder and nipple to nipple enclose the general plane of the chest. The plane, when the body is erect and lungs well inflated, slopes strongly upward. It is wider at the shoulders than at the nipples and contains the front surface of the shoulder, the steplike rise to the chest formed by the pectorals. A slight depression or groove runs over the length of the sternum, developing into a little diamond shape at its base, and this slight groove continues all the way to the navel, separating the two halves of the body.

In the female, the upper part of the breasts should be included in the plane of the chest, the nipple forming the apex of the protruding breast, tending to give a stronger outward direction to the plane of the chest in the female than the male. From the nipples, the line of demarcation separating front from side descends to the highest projection of the arch made by the false ribs, namely, the point where the first false rib joins its cartilage. The thoracic arch is visible in the living model between these points. Below the arch the general front plane is continuous with the abdominal to a point just below the navel, and the direction of this plane is a trifle inward. From the point below the navel, the plane diminishes rapidly in width and slopes decidedly inward between the thighs.

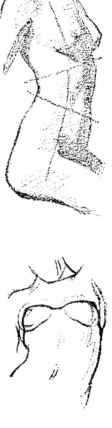

The breast of the female is like a half sphere with a slight tendency to the conical, due to the raised nipple. The breast does not lie upon the front of the body, but in a measure upon both side and front horizontally, and upon the ribs vertically, so that being placed upon the region of transition from front to side the female breasts point away from one another.

The base of the breast thus conforms to the contour of the form upon which it rests. When the figure is foreshortened this is particularly noticeable.

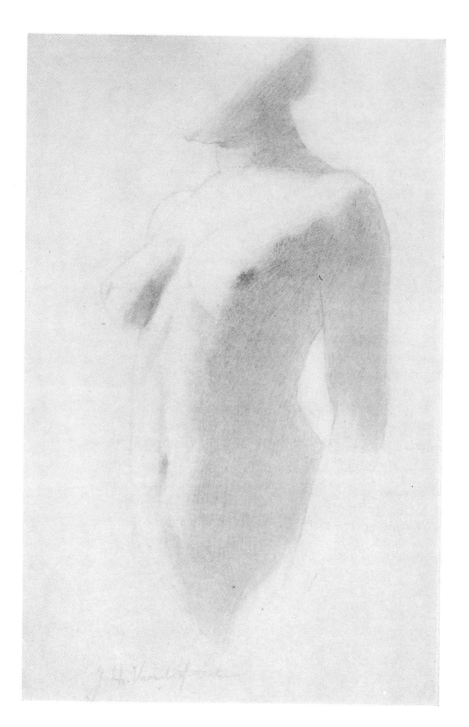

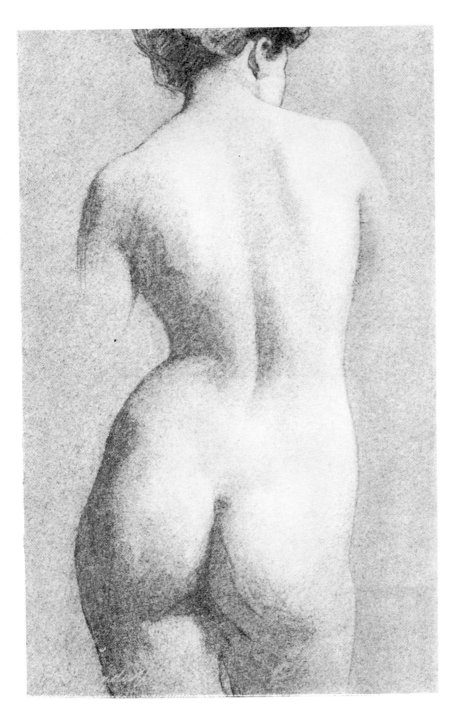

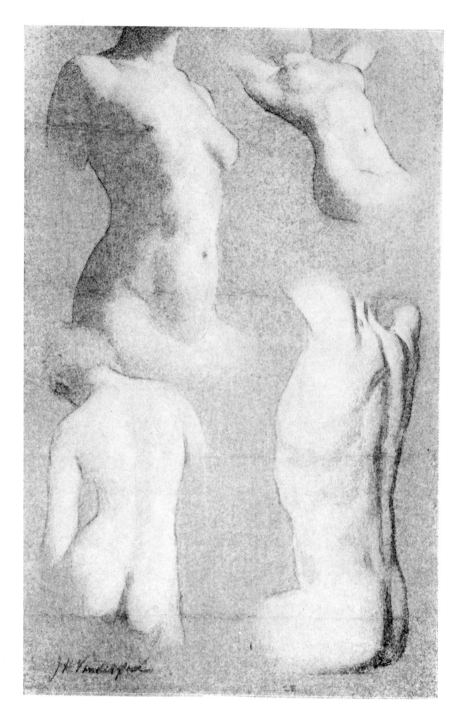

THE TRUNK, BACK AND HIPS

◇

THE depression that runs from the pit of the neck down the length of the sternum and abdomen to the navel, separating the two halves of the body, disturbs the big planes in the front but slightly. In the back, however, the subdivision is much more marked. The spine of the backbone, being subcutaneous, is visible all the way and marks the dividing line between the two halves.

The scapulas, embedded in a deep mass of muscle, add fullness to the back of the shoulders on either side of the spine, giving the appearance of the backbone being quite depressed.

In the region of the small of the back, approached by the tapering form of the back of the thorax, the mass of muscle of either side of the spine collectively considered and carrying out the wedge shape in the back, stands out a step from the hips or buttress form on each side, the apex of the wedge disappearing between the two masses that constitute the buttock. The plane of the buttock has its origin in the sides of the buttress form of the hips that flank the wedge-shaped body, the difference between front and rear being, that in front the wedge is visible all the way, while in the back the buttresses, after leaving the crest of the pelvis, become one, the surface over the sacrum being but slightly raised from the flat surface of the back. At the base of the wedge the buttock becomes subdivided into two rounded masses formed by the gluteus maximus muscles.

The masses of the hips or buttresses that flank the sides of the lower part of the body have their

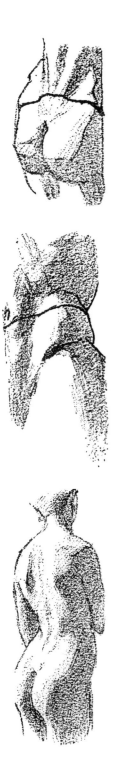

origin at the narrowest part of the body, the waist, beginning with the outward slope of the great oblique muscles. These muscles terminate with the crest of the pelvis, but the thickness of the muscles causes the spine or crest of the pelvis to be depressed, so that the angle of separation of the planes of the upper parts of the buttresses from the lower is above the crest of the pelvis. This angle marks the first stage in the widening of the body in the region of the hip, and from here on the planes descend by means of the gluteus medius, parting less abruptly from one another, due to roundness of the mass, than the above to a point just above the great trochanter or head of the femur.

Over the trochanter again the bone in the living model is marked by a depression, so that the plane of the side of the thigh is not determined by the angle that the bone makes in the skeleton, but by the fullness of the muscle just before its insertion into the aponeurosis, or fascia lata, to which the muscles of the main portion of the buttress are attached.

The rectus is the forward plane or thickness, the gluteus medius the breadth over the hip, and the gluteus maximus the thickness of the back. The plane of the buttress at is greatest width, just below the hip, is not at right angles to the front of the body, but slopes inward toward the back, the breadth of the buttock not being as great as the breadth across the hips. A horizontal section here is a direct contrast to the section across the chest at the nipples. In the latter section, the sides of the body face forward in proportion as the body is broader across the back at the base of the shoulder blades than at the chest, whereas across the hips the breadth across the two thighs is greater than across the buttock. This accounts for the side of

[84]

the buttock being in shadow when the figure is illuminated directly from the front, with the side of the thorax in the light.

In the front of the body the buttresses fall back a step from the abdominal plane, suggesting that, as the abdominal wall stands out in advance of the side of the buttress at its upper end, and the lower part of the buttress behind protrudes beyond the small of the back, the buttress itself must slope forward from below up. So that the sections of the two parts are by no means directly above one another and the center of a section just below the crest of the pelvis will fall back considerably behind a section across the waist.

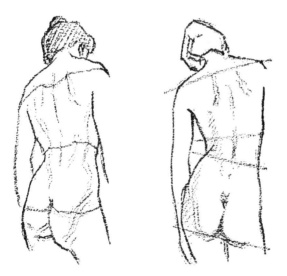

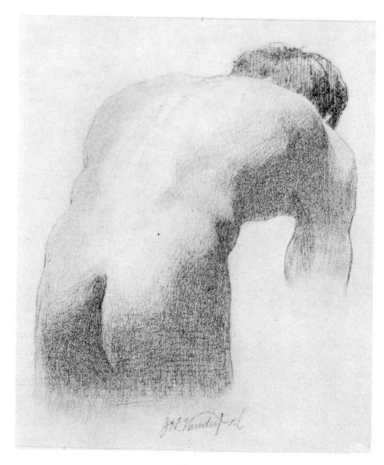

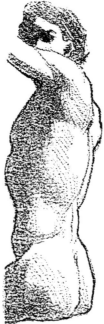

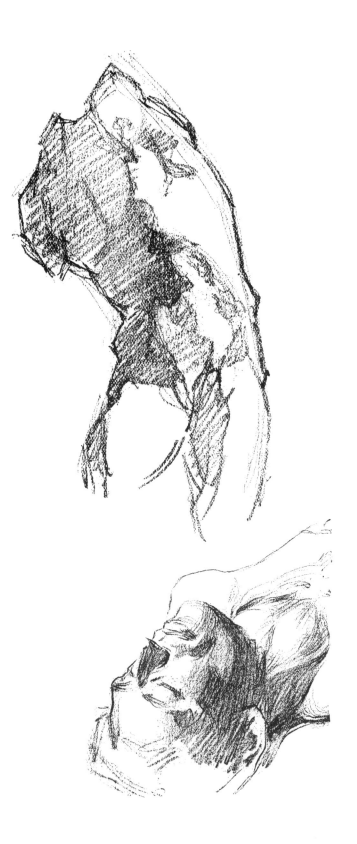

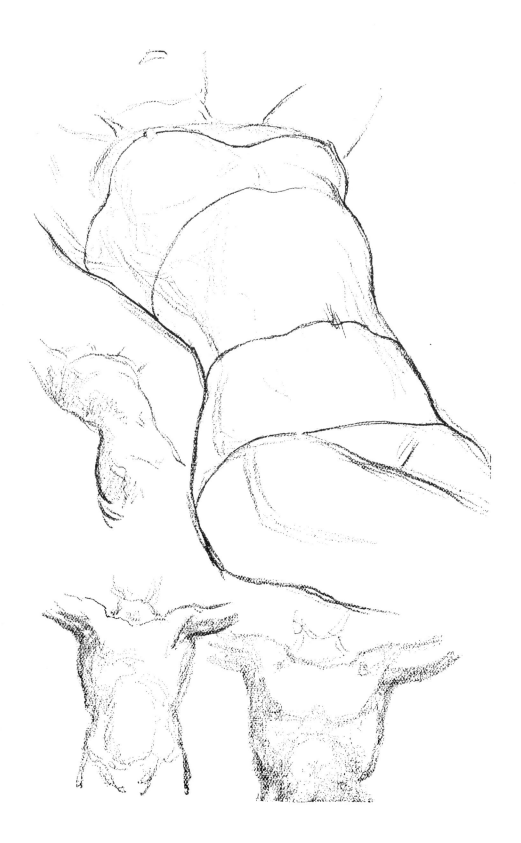

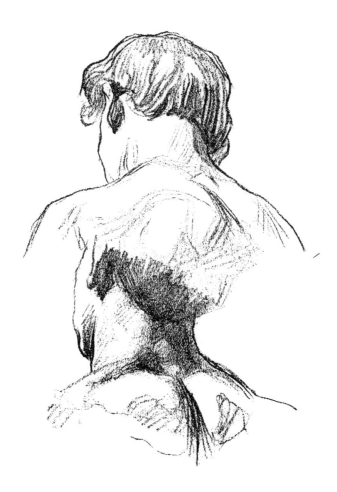

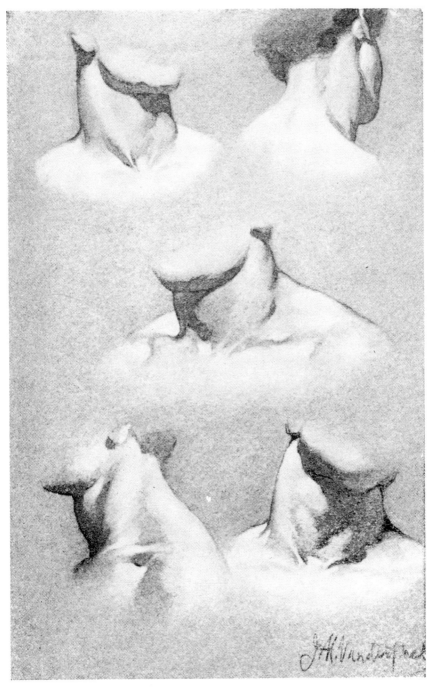

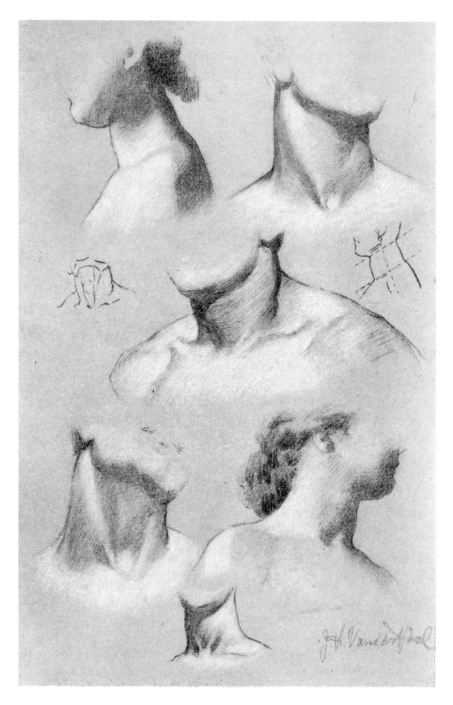

NECK, THROAT AND SHOULDERS

◇

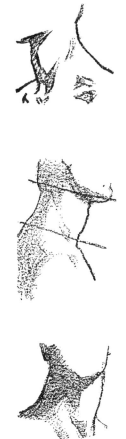

L EAVING the conventionalized diagrams of the body, and having through their use discovered the nature of the great planes which encompass it and give substance to the forms, we will now consider the component parts or contents of these planes in detail.

The neck and throat too often receive but slight consideration on the part of the student, being treated as if they were other than a distinct form like the arm, leg, etc. The firm attachment of the neck to the body at the back is no doubt the occasion of this, the trapezius rising high upon it, so that the neck proper is much shorter in the back than in front.

The carriage and action of the head is controlled by and depends upon the neck, and it is so constructed that the utmost freedom and variety of movement is possible. It should therefore be kept in mind that the bony structure of the neck is a continuation of the vertebral column and partakes of its supple character, so that the neck partakes in a greater or lesser degree of whatever action is conveyed by the head. A certain type of individual may hold the neck rigid with the body and nod the head in greeting, so that all the action will be confined to the junction of head and neck, and such an action may be in character with the man, but it is not common.

The male neck is short, thick and firm, rising almost vertically from the body, while, on the contrary, in the female the neck is long, slender and graceful, leaving the body with a greater forward direction.

[93]

In a general way the form of the neck is cylindrical, though it manifests more or less angularity of plane, particularly in the male. It tapers like a column from the base up, with a slight swelling in the center of the sides, caused by the fullness of the sterno-cleido-mastoid muscle, and in front by the Adam's apple.

As the base of the skull is higher at the back than at the chin and jaw, and the pit of the throat above the head of the sternum is lower than the base of the neck at the back (the vertebra prominens), it is discovered that the plane of contact of the neck with the head is parallel to that of its contact with the body, both sloping diagonally, not quite at right angles with the direction of the neck.

In the front view the sides of the neck are symmetrical structurally. When in action, as throwing the head back, to one side, or turned upon the neck, though the evidence of structural symmetry remains, the lines enclosing the form are radically different. In the profile the lines that enclose the front and back vary greatly. The front line is convex in the region of the Adam's apple, while diagonally opposite is the deepest part of the concavity of the back, giving to the whole form a suppleness so characteristic of a well-formed neck. The body of the neck is shorter in the back than in the front, and at is connection with both body and head flares outward, making its connection the more complete.

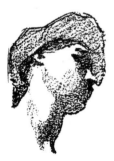

The trapezius, or the great neck and shoulder muscles, produce at their junction at the base of the skull the flat plane of the neck containing a slight gully. In contrast to this depression and at the base of the back of the neck is found the last cervical vertebra—the vertebra prominens.

The trapezius rising diagonally from the spine of the scapula or shoulder blade immediately opposite the attachment of the deltoid, supports the neck at its sides with its buttresslike forms, giving it an appearance of great strength and power and connecting it intimately with the body.

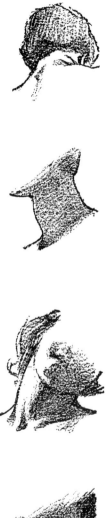

The sterno-cleido-mastoid, the muscle that pulls the head sidewise and turns it upon the body, produces the fullness upon the sides of the neck, as it descends diagonally from the side of the base of the skull, back of the ear, to the sternum or breastbone and clavicle (for it subdivides a tendon going to each bone). A gully is formed in the otherwise full formation of the neck at the sides between the trapezius and the mastoid, which deepens into quite a hollow upon reaching the clavicle, where the bone makes a reverse curve to meet the shoulder-blade, and this depression continues below the clavicle and marks the separation between the deltoid, the mass of muscle that surrounds the shoulder, and the pectoral or muscle of the chest.

In front, at the base, the cords of the mastoid muscles become very evident, walling in between them the pit of the neck, out of which rises the mass of the Adam's apple.

A section of the neck across its upper half will disclose the convex projection of the Adam's apple in front and a depression in the nape of the neck behind, while in the lower half we find a depression in the form of the pit of the neck in front and a projection made by the vertebra prominens behind, a reversal of incidents.

In the region of the pit of the neck are found three kinds of forms in close conjunction, the muscular, tendinous and bony, to the drawing and rendering of which careful attention should be giv-

en. If too bony, the forms will look hard and attenuated; if too soft they will appear character-less. Note the outward flare all around its base at the entrance of throat into body, which gives it a sense of attachment, suggestive of a tree that grows from the ground rather than a pole that punctures it.

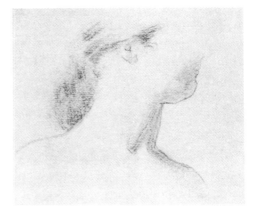

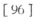

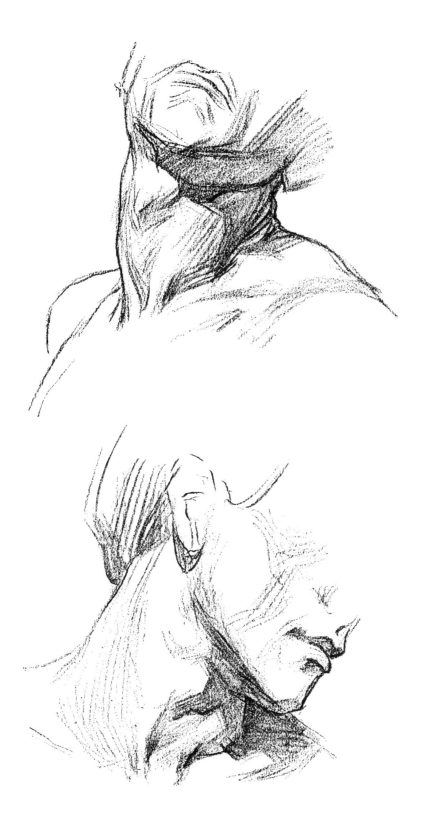

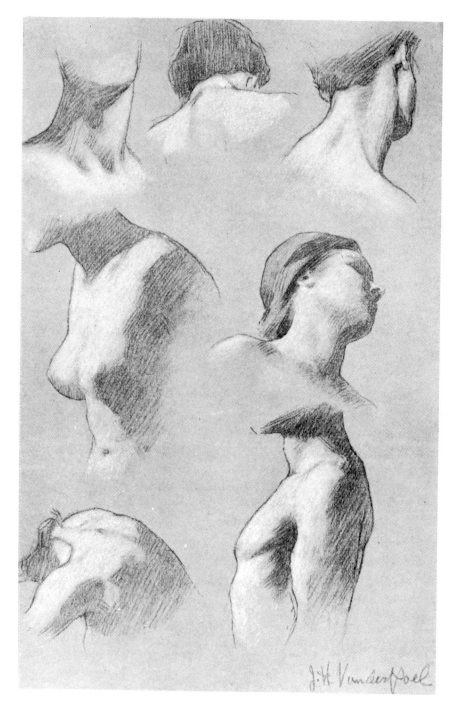

THE SHOULDERS AND CHEST

◇

W E now come to the first articulation of the body proper, that of the shoulder. The junction of the humerus, the bone of the arm, with the scapula, and scapula with clavicle, should be carefully studied to enable the student to comprehend the planes presented in the living model. Parts of these bones come well to the surface, and to be interpreted must be well understood. The clavicle is visible along its whole length, particularly at the reverse curve approaching the outer end. Below it at this point is a depression which marks the separation of deltoid or shoulder muscle from the pectoral or muscle of the chest. The junction of the clavicle and scapula too is quite visible, and the head of the humerus, which forms the apex of the shoulder, aserts itself beneath the deltoid muscle.

The clavicles and scapulas nearly encircle the region of the shoulders, enclosing between them the thickness of the upper extremity of the body, the plane from out of which the neck emerges. This plane rather eludes observation because of its diversified nature. Its surface faces upward and somewhat forward, higher at the back than in front, in keeping with the direction of the base of the neck. The plane is broken by a triangular hollow bounded by the lateral base of the neck, in front by the inner border of the clavicle as the latter turns from the chest to the shoulder and at the back by the trapezius, which acts as a buttress on either side of the neck as it descends to the shoulder. This hollow is the gully referred to in the preceding chapter. The plane is flat and nearly horizontal at the shoulder, but the remainder slopes decidedly, rising

from the pit of the neck to the juncture of back of neck and trapezius, its direction being about at right angles to the axis of the neck.

The cone of the thorax or cage of ribs punctures the shoulder girdle, the ribs of this conelike shape appearing above it. It is the direction of the first rib, leaving the head of the sternum or breast-bone just below the clavicle and rising to the vertebra prominens, that gives decided direction to the upper plane of the body. The contour of this upper plane of the thorax is greatly affected by the bones of the shoulder girdle and assumes greater singularity where they come to the surface. The clavicle describes a reverse curve; combined and in position they follow the convexity of the cone of the thorax.

Combined, the clavicles form a Cupid's bow. Leaving the plane of the chest the clavicle curves backward, following the ribs for a short distance, and then reversing its curvature extends laterally from the body and joins the scapula and humerus articulations which form between them the mass of the shoulder. The scapula is triangular and is slightly convex, having a spine diagonally across its upper part which extends beyond it and curves around the outer end of the clavicle, to which it is attached. The two scapulæ repose upon the ribs at the turning point from back to side, in such position that a wide space is left between them, in the center of which is found the spine.

Beginning with the neck as an elongation of the cone of the thorax, its section is circular, with flattened sides. At the entrance of neck into body we come upon the buttress form of the trapezius, changing the form of the section by a broadening at the base of the neck. Descending to the region of the shoulder girdle, the section includes the

shoulders, giving it much greater breadth in proportion to depth. The coming together of the clavicle and the spine of the scapula makes the projecting or epaulet form of the shoulder, which at the same time marks the beginning of the length of the arm, through its attachment to the body by means of the mass of the deltoid.

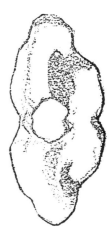

When standing erect, chest out, the plane of the shoulder or epaulet form is set well back of the chest; on the other hand, the posterior plane becomes quite continuous with the plane of the scapula. We find then that the chest, from the middle region of the shoulder girdle to the nipples at the base of the chest, makes a great plane broken by the retiring shoulder, placed steplike but parallel, back of the plane of the chest; that is, the center of the shoulder is set back of the center of the body. On the other hand, in the back, the great breadth of the shoulders is smooth at the extremities and broken in the center by the sunken spine between the inner borders of the scapulae and immediately opposite the simple plane of the chest.

In the erect figure, the length of the scapula, as seen in the profile, is well-nigh vertical, sloping only slightly outward and downward. On the contrary, the chest slopes well outward, its direction corresponding to the position of the dorsal vertebræ which make a decided forward sweep to the small of the back. The squareness of the shoulders is common in the male, whereas sloping shoulders are more characteristic of the female.

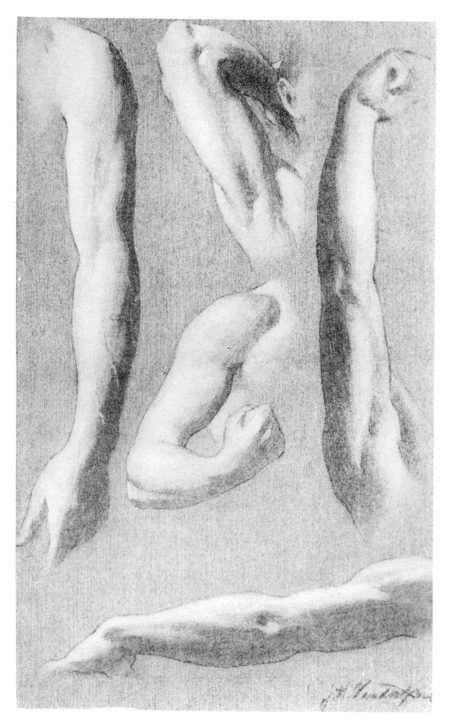

THE SHOULDER AND ARM

◇

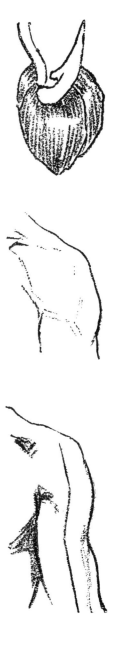

THE deltoid clothes the articulation of the shoulder and forms, with the pectoral and long portion of the triceps, the main attachment of the arm to the body. Imagine the deltoid detached and flattened, and it resembles an inverted arrowhead with its apex inserted a third of the way down the length of the humerus on its outer surface, between the biceps and the triceps; the barbs rising, and enclosing between them the juncture of clavicle and scapula, to whose outer borders they are attached. This attachment occurs immediately opposite to that of the trapezius from above.

The pressure of the head of the humerus under the deltoid, just below the junction of scapula and clavicle, forms the outermost point of the shoulders, and the breadth of the shoulders proper lies between these points.

In comparing the proportions of the sexes, it is stated rather inaccurately that the body of the male is broader at the shoulders than at the hips, and that in the female this relationship of breadth is reversed. From this we may infer that the mass of the deltoids enclosing the shoulder may be considered as a part of the body, inasmuch as they establish its breadth. Unlike the other parts of the trunk, the shoulder is not rigid with it, but, on the contrary, is capable of great movement, and may be raised and lowered, or thrown backward and forward. In fact, it is only in repose that we feel the shoulders' close relation to the body; but upon the least sign of action in the arm, the mass of the shoulder immediately participates in it and becomes in turn a part of the length of the arm.

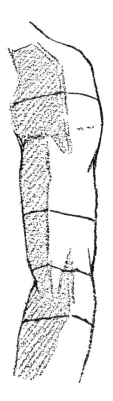

The mass of the deltoid and its bony structure within plays the double function of belonging to the body in establishing it's length, the head of the humerus forming the angle where the length of the arm begins and breadth of the shoulders terminates.

In the drawing of the arm, after noting its general proportion, that is, its average thickness in proportion to length, and the mass of the deltoid located at its highest point, which point is on a line with the arm-pit, observe the degree of taper that extends from the greatest thickness at the shoulders to the wrist. The tapering in a fleshy arm is more rapid than in the slight one, because the adipose is not distributed equally along its length, the thickness of the wrist varying but little with the accretion. In the arm of a slight youth this tapering is most subtle and taxes the utmost skill of the trained artist.

Having noted the tapering form of the arm as a whole, it will be discovered that each part of the arm in turn tapers from above down, thus producing the general taper in the arm as a whole. In detail, irrespective of point of view, the upper arm from the apex of the shoulder attains its greatest width or thickness in the fleshy region of the deltoid. In the strongly developed arm the form is firmly marked; in the slight one it is only delicately marked by an outward direction from the apex of the shoulder to the most prominent point of the deltoid, the beginning of the length of the arm.

From the detachment of the arm from the body, at the arm-pit, just opposite its greatest fullness at the deltoid, the arm diminishes gradually in width to the elbow; this, however, is more notice-

able in the profile than in the front view. The fleshy mass of the forearm near the elbow widens in excess of the breadth of the upper arm and in turn diminishes in width to the wrist. In the well developed and hardened arm the planes become very evident, in fact more so than in any other fleshy part of the body.

The interlacing or dovetailing of the parts in the arm is one of its most interesting features. It has been noted that the barbs of the deltoid flank the front and back of the shoulders. Its heavy outside mass, which projects beyond the flat surface of the upper arm, terminating in a point, descends and is inserted between the biceps and triceps, and these muscles, in turn, rise above the insertion of the deltoid and pass underneath its triangular borders. Again the biceps descends and is inserted mainly into the forearm between the two cushiony forms of the supinators and pronators, which pass it in their upper attachment, particularly the supinator longus, which rises above the articulation and is inserted on the outside of the humerus on a line below the deltoid insertion.

In the horizontal section of the region of the shoulders the three exposed surfaces or planes form a square with rounded corners. Across the region of the biceps the section is less deep than it is broad, that is, the thickness of the arm here is less than the breadth from biceps to triceps, but the thickness in the back exceeds that in front or across the biceps. At the elbow and immediately below, where the forearm is the heaviest, the thickness in proportion to breadth is reversed, and the two forms, of the upper and lower arm, by means of the biceps in front and the supinator longus on the outside, dovetail into one another. At the wrist the breadth, parallel to the back of

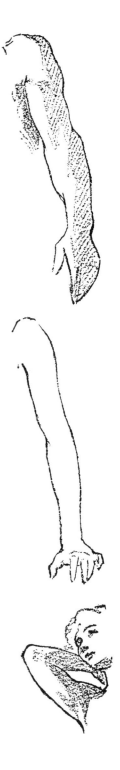

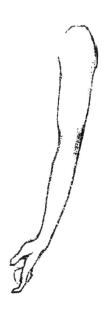

the hand, is greater than its thickness. The change from the greatest fleshy breadth and width of the forearm to the tendinous form two-thirds of the way down to the bony and angular wrist, is characteristic of both the forearm and the lower leg.

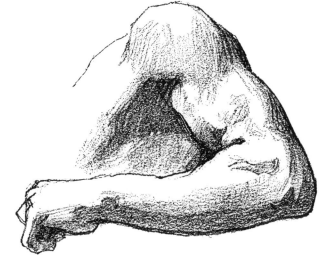

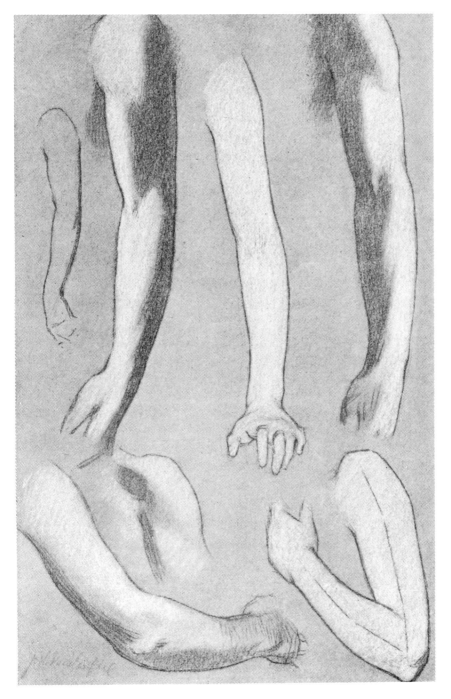

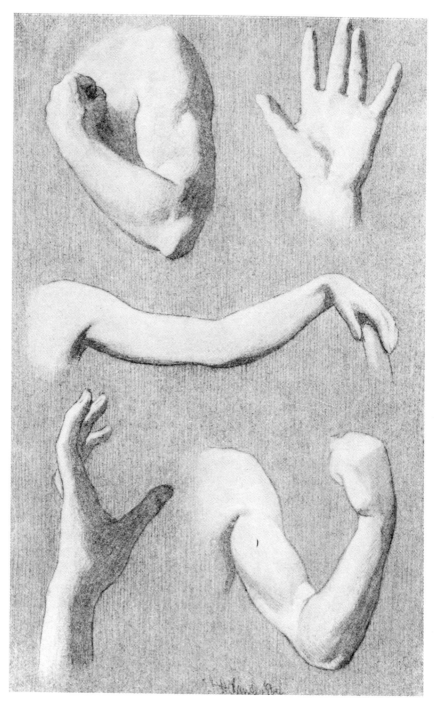

THE ARM, WRIST AND HAND

◊

THE forearm is heaviest immediately below the elbow. The mass is convex at the back and concave in its front plane when the arm is straight; a slight depression locates the insertion of the tendon of the biceps between the lateral masses of muscle, composed on the outside of the supinator longus and radial extensors, and on the inside of the round pronator and palmar muscles. About half way down the length of the forearm, these with many other muscles, terminate in tendons, which closely hug the arm bones and pass under the ligament at the wrist, which holds the tendons firmly as they go into the hand.

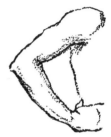

The transition from muscle to long tendons accounts for the graceful tapering of the forearm. At the wrist the bones coming close to the surface makes for greater angularity of form, the wrist being nearly twice as broad as it is thick in the muscular arm. The carpal bones form the bony structure of the wrist proper, placed between the bones of the arm and the metacarpus, which is made up of bones of the body of the hand.

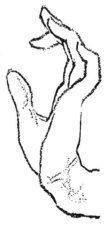

The common error of the youthful draftsman in forming the arm lies in drawing the parts too detached, giving the appearance of its being hung on at the shoulders, as on a doll, and as if broken at the elbow when the arm is bent; same with the wrist, if considered at all, for too often the hand hangs from an arm minus a wrist.

It will be noticed in the front view of the arm, when in repose at the side of body, that the deltoid in its fullness slopes outward from the apex

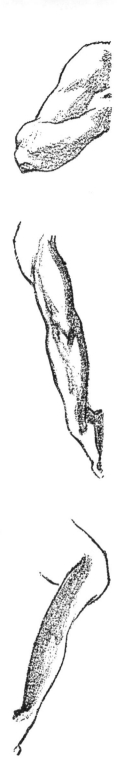

of the shoulder.. This slope exceeds that of the arm, irrespective of its position, and helps greatly to give the feeling of attachment. In supination the forearm is at an obtuse angle to the upper, and the forearm is thrown slightly away from the body. With the arm in that position, front view, note the direction of the principal masses.

As observed above, at the shoulder the deltoid slopes outward in excess of the upper arm. Just before its insertion it makes a return curve, and this inward slope is repeated by the upper and inner part of the triceps, which forms the inner mass of the arm and fills, as it were, the arm-pit. The mass of the shoulder projects like a ledge beyond the body, with the arm inserted into its under surface, and the center of the point of attachment comes a trifle inside of the center of the shoulder.

The student's intention should be to convey in his drawing the great masses of form; in the arm, he should look for long lines that will convey the true proportions of the dimensions as affected by action. It is difficult at first not to stop at the elbow in drawing the above, the supinated position of the arm; therefore, instead of stopping at the inner condyle, draw a line from the arm-pit to the greatest fullness in the forearm well below the elbow. Give this line a slight convexity, its greatest curvature touching upon the condyle.

The subdivisions along the outer border are more numerous, and no difficulty will be found in conveying the location of the elbow joint if these masses and subdivisions are truly related. Continuing along the outer border from the inward direction of the deltoid, the line runs nearly parallel with the inner line, the two lines enclosing between them the shaft of the upper arm; but the outer, differ-

ing from the inner line, falls short of the elbow, and is intercepted by the raised form of the supinator longus. The supinator rises from the shaft as the deltoid falls to it; the depressed border, the outer edge of the triceps, between them gives appearance of a concavity in the outer form of the arm in contrast to the convexity of the inner.

It will be noticed also that the most prominent point of the deltoid is a little lower than the arm-pit and that the fullest point of the supinator is higher than the greatest fullness of the inner border below the elbow. Lines drawn through these points will be found to cross the central direction or axis of the arm nearly at right angles. From the fullest point along the inner border the line runs quite smoothly to the wrist, but along the outer the decrease of the thickness of the supinator must be noted before reaching the line of the wrist.

The arm holding scroll gives a good idea of the sweep that runs through the center of it, intensified by the action.

Again, in the profile the mass of the deltoid, the direction of which may be marked by a line drawn from the center of the shoulder above to the central point at level with the arm-pit, leans forward slightly, in accord with the forward movement of the mass that rises above the scapula as it melts into the neck. The line that marks the junction with body is a little higher at the back than at the front, being at right angles to the direction of the deltoid or shoulder. This gives the appearance of firmly attaching the arm to the body.

The shaft of the upper arm, that portion of the arm containing the biceps and triceps, located between the deltoid and supinators (the fleshly fullness over the outside of elbow-joint) falls in from

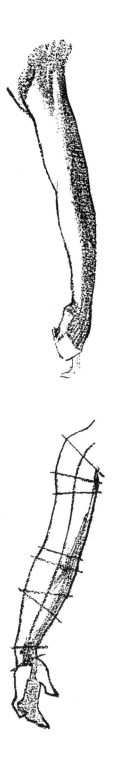

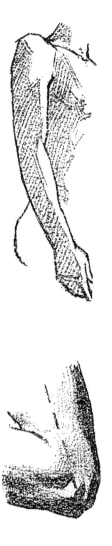

the shoulder, that is, its center is not immediately under the center of the shoulder.

When in action the many parts of the arm show their intimate interrelation to one another. An artist's arm may almost be in repose, only the finger tips being used in executing some deft touch, but the next moment the action includes the whole length of the fingers, the wrist, elbow, including the act of pronation or supination, and finally the shoulder. He may make a master stroke requiring a sweep from the shoulder, but each joint, each set of muscles to the sensitive finger tips, lends its aid to give to the supple movement of his stroke the desired character and quality. So in a drawing, every part of the hand and arm must be in character both in form and action. No matter how definitely the forms may be distinguished, by name, location, shape and proportions, they must in practice interrelate under the surface of the continuous skin, sometimes partially lost through a connecting curve. sometimes accented by abrupt angularity, but always connected.

The arm must never look as if pinioned, suggesting that it can only move parallel to the side of the body. The elbow in the flexed arm should not suggest through its irregularity that the arm has been broken in order to locate it. The olecranon, or point of the elbow, should be found under the center of the shaft of the upper arm when the forearm is flexed upon the upper, and not on a line with the back of the arm. This continues the sense of connection.

THE HAND AND WRIST

◇

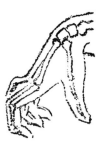

THE hand, equally with the head, should receive special attention, for the reason, first, that it is generally seen; second, because of its character and the part it plays in expressing an emotion or action; and thirdly, because of its intricacy and the difficulty, due to its numerous parts, of handling it in masses and planes, except when the hand is closed.

The double row of carpal bones is the means of attachment of hand to arm and may well be named a universal joint, for it permits of an up-and-down, side-to-side, and rotary motion, and, in conjunction with the supination and pronation of the forearm, permits the hand to partake of any action desired. But it also enters into the large movements of the arm, giving grace and suppleness, or vigor and power, as the action is transmitted by means of the wrist to the hand.

When the hand, palm down, and the arm rests upon a table or flat arm of a chair, the wrist does not touch the surface — the mass of the wrist rises from the hand at an obtuse angle to the arm, meaning that the center of the body of the hand is a step below the center of the body of the arm at the place of attachment. This is the relative position of hand to arm when held in continuous direction with the arm. When the hand is raised the wrist takes an upward turn or sweep, and when lowered a downward one, and a graceful curve connects the two no matter what the position.

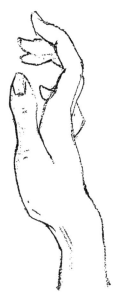

The body of the hand is larger on the side of the thumb than on the side of the little finger, the

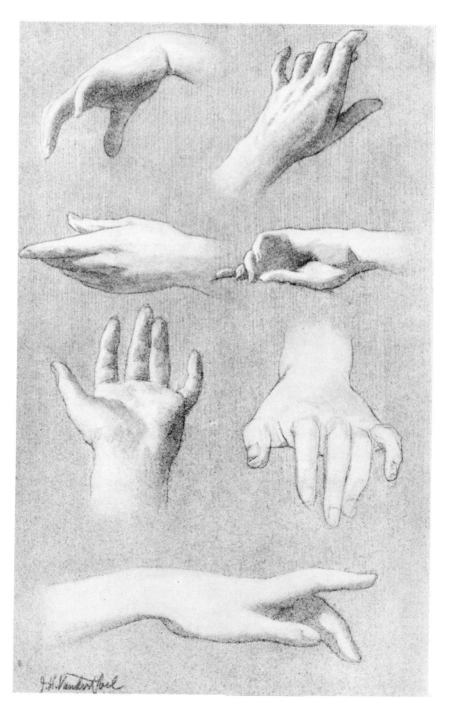

palm is longer than the back, broader at fingers than near the wrist, and thicker at the wrist than near the fingers.

The back of the band is quite flat except when the hand is clenched, though it assumes consider-able convexity upon connection with wrist; the palm, on the contrary, is like a shallow bowl with squared sides, well cushioned on both sides near the wrist.

Collectively the fingers taper, and the tip of the middle finger, the longest, forms the apex of the mass. Each finger tapers in itself with a tendency to converge toward the middle finger, though when the hand is in action the middle and third fingers are inclined to go together. In the act of clenching the hand the finger ends point to a common center.

The length of the first joint of the fingers is equal to the two remaining ones, but the palm ex-tends half way up the length of the first joint, giving the appearance on the inside of the fingers of all the joints being of equal length.

The whole length of the thumb is equal to the length of the middle finger, measured outside, and reaches to the middle joint of the first finger. The body of the thumb is much heavier than that of the fingers, and unlike them does not taper, except the last joint.

The sections of the fingers are more square than would seem, though the last joint, containing the nail, is quite triangular, the nail with the flesh on either side forming the base and the sensitive cushion on the underside the apex. From the fact that the hand contains so many parts and is capable of an infinite variety of actions, and is so varied in character (for hands are no more alike than faces) the student will readily see the importance of being familiar with its construction.

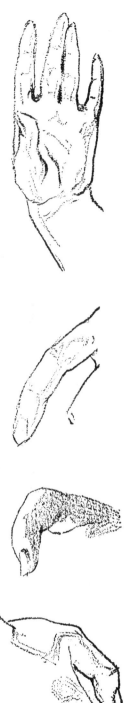

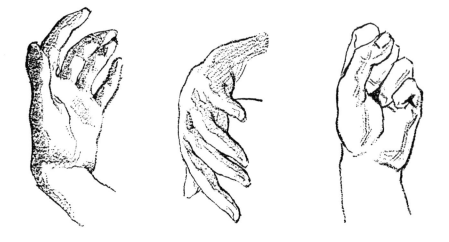

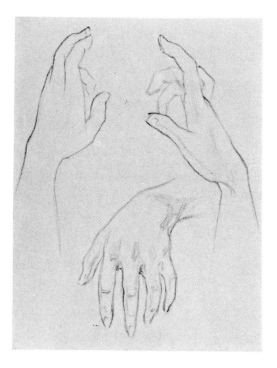

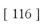

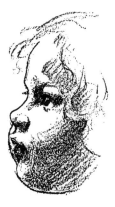

[117]

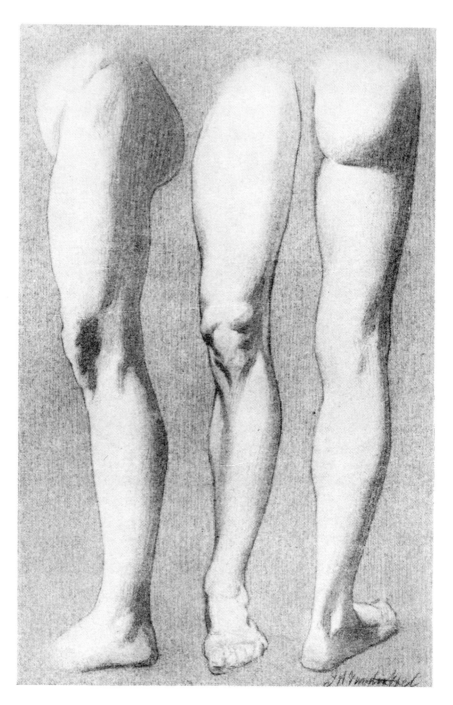

THE LEG

◇

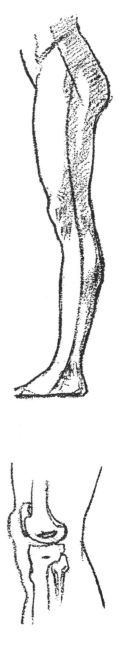

THE degree of taper in the leg as compared with
the arm, is greater, as the leg at the thigh is
heavier, compared with the ankle, than the upper
arm compound with the wrist. In a general way,
the changes that mark the diminishing widths are
not dissimilar. The arm tapers slightly to the el-
bow; the leg, in proportion as it is heavier, tapers
more rapidly to the knee; the mass of the calf more
rapidly, in proportion as the calves are heavier than
the muscles of the forearm. In the leg, too, the
alternation of flesh and bone are more noticeable
than in the arm.

It will be observed that when the leg receives the
weight of the body, the knee is pulled back. A re-
verse curve runs through its entire length, from
trunk to ankle, the knee forming the point of re-
versal. The femur or bone of the upper leg de-
scribes a curve with its convex side directed for-
ward; this convex curve is intensified by the great
mass of the rectus femoris muscle in front and
by the corresponding concavity at the back, made
by the overhanging of the buttock (the gluteus
maximus) above, and the propecting calf below;
there is a local fullness on the back of the thigh
made by the biceps, but in no way so conspicuous
as to interfere with this generalization.

The bony mass of the knee is the pivot upon
which the curve reverses. If the convex curve of
the thigh is described from it's attachment to the
level of the base of the knee, so the concave reverse
curve of the lower leg begins on a level with the
top of the knee and descends with a forward sweep

[119]

into the instep. In the outline of the front of the lower part of the leg, which corresponds to the reverse curve described, there is a local fullness made by the crest of the tibia overlapped by the tibialis anticus muscle; but care should be taken not to make it over-conspicuous, or the concave effect made by the overhanging knee and the forward sweep of the ankle will be lost. Naturally, the convexity of the calf opposite the deepest part of the forward line completes the spirit of the reverse curve.

The interlacing of the parts of the leg is well illustrated in the forward part of the thigh descending to the lower part of the leg by means of the knee-pan and terminating with the kneeling point; on the other hand, on the back the mass of the calves enters the upper part of the leg on a level with the upper border of the kneepan. As these structural masses interlace, so do the planes that come into existence through them.

In the front view, the attachment of the legs to the body is marked by diagonal division lines descending on each side from the crest of the iliac or pelvic bone to the pubic arch, wedging between them the lower abdominal mass. The inner border of the leg is broken by minor forms which deviate but slightly from a straight line. It is in the outer border that the large changes are found, beginning with the long line from the head of the femur to the knee, continuing with the line to the widest part of the calf, and thence with the line to the foot. Such simple lines enclose the great masses and mark the degree of taper.

In detail, the thigh, as it descends, tends slightly inward to about two-thirds its length, when it makes a greater inward turn to the knee. The mass

of the knee takes an opposite direction, diminishing slightly in width, as it also does in profile.

The crest of the tibia coming well to the surface descends from the kneeling point, making an inward sweep as it forms the inner ankle. Partly in front of the fibula (the outer bone of the lower part of the leg) the mass of the calves envelopes the sides and back of the bones, widening rapidly from the knee to about a third of the length between knee and ankle, the outer calf being higher than the inner. The inner calf terminates with abrupt fullness upon entering the shaft of the leg, whereas the outer calf turns into it more smoothly. The tapering shaft turns gracefully inward as it enters the foot.

The planes composing the mass of thigh are well rounded, but upon approaching the mass of the knee they become more angular and defined, the planes at the sides from knee-pan back being quite flat. This is the case when the leg is extended. When the knee is bent, the knee-pan sinking, discloses a broader bony surface across the front.

The backs of the calves are quite convex, rounding as they enter the flat surfaces on either side of the crest of the tibia. The shaft of the leg just above the ankle is quite round, changing into more angular surfaces at the ankle and entrance into the foot.

When the leg is standing on the ball of the foot, or advanced with extended toes, the instep, though slightly convex, becomes continuous with the front line of the leg and marks an intensification of the reverse curve along its length to the great toe.

This long curvature is but delicately broken by the knee, though in the male it is more ruggedly marked than in the female. Along the back, how-

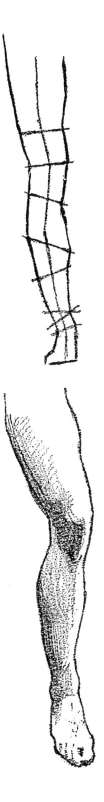

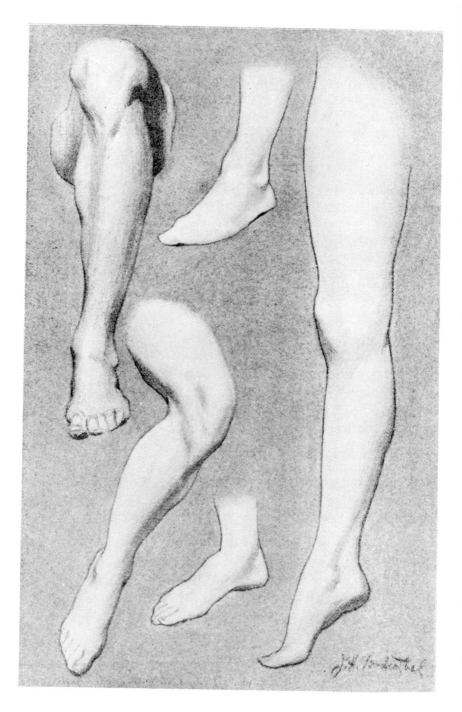

ever, the accents are retained and in the case of the heel at the junction of leg, the heel being flexed on it, the angle is greatly emphasized.

In fact, whereas in the front all the parts melt into one another, the line remaining simple in expression, the big form at the back the length of each part of the leg is designated by an angular separation, alternately going in and out, diminish-'ng in width in stages to the toes; the line of the back of the thigh approaches the front line, going in; the length of the calf is made by a line sloping outward; the shaft of the lower leg is made by line from the calf to the heel, tapering greatly to the ankle; then follows the angle of the uplifted heel to the sole of the foot and from there the line tapers to the toes.

When the lower leg is flexed upon the upper, the bony mass of the knee becomes much more evident, the lower end or condyles of the femur showing plainly on each side of the patella or knee-cap; the latter, though visible because the skin is tautly stretched over it, sinks partially into the groove of the lower end or condyles of the femur. Both condyles are in evidence, as well as the head of the fibula, which shows very plainly just below the outer condyle.

In the profile both the upper and lower leg retain their convex and concave curvature irrespective of the action, though the sinking of the kneepan makes the convexity of the upper part of the tibia somewhat conspicuous. This reversal of the arched form of the parts of the leg should be given special attention, for, unless the quality of suppleness of movement be appreciated, the forms will be made stiff and rigid. The parts fuse so gracefully into one another that any stiffness of action immediate-

ly suggests ossification of the part. For instance, it has been seen that the thigh curves with its convex side forward; the lower leg on the contrary has its convex side at its fullest in the calf at the back.

The controlling movement of the leg is marked by the simple front line. It is most convex a little above the center of the thigh and most concave a trifle below the kneeling point, when the leg is straight.

The back surface of the thigh is sunken between the lower part of the back and the calf, and hence combined with them describes a concavity as opposed to the convexity of the front, keeping the spirit of action intact. However, this does not signify that the local fullness in back of thigh should remain unnoticed; on the contrary, it should be insisted upon; but remember it is only a local form, and does not complete in importance with the fullness in front. In the lower leg the reverse of the thigh curvature controls; the fullness on the tibia should not compete with the much greater fullness of the calf at the back, for if it does, it inevitably results in stiffness.

Again, the entrance of leg into the foot by means of the ankle deserves much attention. In the profile, it will be noted that the rounded form of the ankle enters the foot well back of its center and at a slightly obtuse rather than a right angle. In a word, the main direction of the leg upon its entrance into the foot is forward or outward, thereby throwing the weight of the body rather upon the arch than the heel alone.

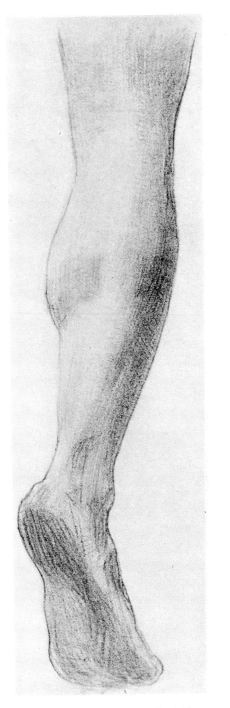

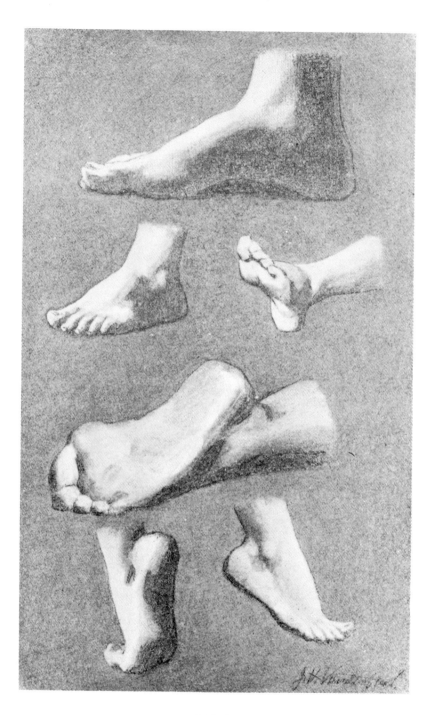

THE FOOT

◇

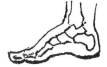

THE main body of the foot is formed in the shape of an arch, the ball and heel answering to the piers on which it rests. It is broadest across the ball, tapering forward into the mass of the toes; the second toe, being the longest, forms the apex of the group. From the ball backward the width diminishes gradually to the rounded surface of the heel.

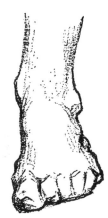

The inner surface of the foot is nearly vertical as it rises to the ankle; broken below by the hollow of the arch of the foot and above by the protruding bone of the ankle. The outer surface is less flat and slopes decidedly toward the ankle in its rise. Here, too, the ankle protrudes, but is on a lower level than the inner one.

At the base of the inner surface, the rim of the ball of the foot and heel only touch the ground, while the rim along the outer surface touches all the way. When the full weight of the body is thrown upon the foot, it shows considerable spread at the ball and heel; the toes also have this tendency, aiding greatly in giving equipoise to the body. If a line be drawn through the center of the sole of the foot, it will be noted that the direction of the ball crosses it diagonally, the inner part of the ball, containing the origin of the great toe, being well in advance of the outer.

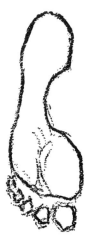

A study of the sole of the foot plainly shows the points of contact with the ground; first, the rounded heel, the outer rim connecting it with the ball; then the ball itself, which is subdivided, the inner portion being the larger; and, last, the under-surface of the end of each toe.

[127]

The top of the foot or instep, extending from the entrance of leg into foot to the toes, is in the main triangular; its inner border rounding rather abruptly into the side of the foot, its base line slopes backward in degree as the little toe is set back of the big toe. The outer surface slopes in rapidly from the base toward the ankle and outer edge of the upper surface, the two surfaces melting into one another near the little toe.

There now remains the surface of the back of the heel. This plane is widest at its base, tapering slightly upward and more rapidly as the heel is joined to the Achilles cord, which connects the heel with the leg. The location of the entrance of the leg into the foot, as seen in the profile, is noteworthy, in that it is well back of the center of the arch; second, when the foot receives the weight of the body, the leg does not enter it at right angles to the sole. A sense of flexibility and elasticity should characterize the articulation of the ankle, otherwise the form will appear stiff and ossified.

A line drawn through the center of the leg as it enters the foot should lead the eye into the forward part of the foot at an obtuse angle, following the curve of the ankle as it enters the instep. This appearance throws the weight of the body

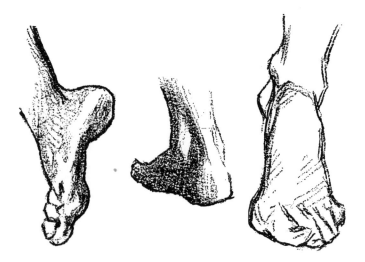

upon the curve of the arch, just back of the center, throwing the pressure to the ball of the foot diagonally across the arch, rather than to the heel. In jumping, the ball of the foot receives the impact, not the heel. In the extended foot, when seen in profile, the arch of the instep becomes continuous with the forward line of the leg, leaving it with a delicate reverse curve. In this action, the angle of the heel to the leg is the more pronounced in proportion. In such an action the ball of the foot, aided by the mass of the toes, receives the entire weight of the body.

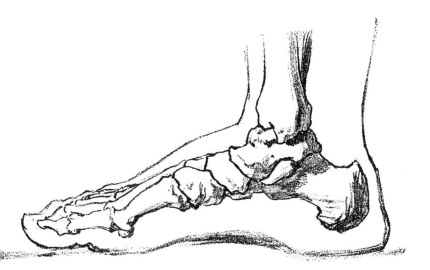

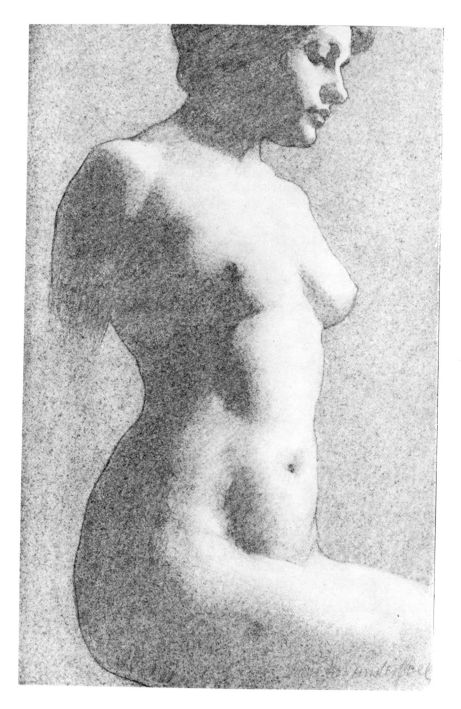

THE COMPLETE FIGURE

◇

IN the beginning of a drawing of the entire figure, it is interesting to note how secondary the component parts become in their relation to the whole. Not that their value, beauty, delicacy or strength have diminished, but relatively they now assume a less imposing aspect; they now truly take their place as subordinate to that vital quality which holds our first attention when we behold a beautiful figure in action.

In the infinite variety of action of which the human figure is capable, the minor parts fuse into the greater in the most subtle manner, leaving us in doubt as to the moment of separation or as to which is the more important for pictorial use. So the lines that encompass the smaller parts melt into the larger and become part of them. That is true of every degree of form, from the minutest detail to the largest mass; each form becomes a part of something larger than itself. Even a form, than which locally none is more important, may be so submerged in a strong action as to lose all or a great part of its importance.

The detail of the under line of an upraised arm may be dominated by its becoming continuous with the line of the side of the body; the line of the back of the neck when the head leans slightly forward continues with the plane of the shoulder and becomes one with it. In this manner planes and lines, no matter what the action, or the direction of the illumination, are extended from the trunk or body to the arms, legs and neck.

The profile of a simple figure standing erect,

hands behind the back, or hanging at the side, chin down, head and shoulders back, chest out, stomach in and heels together, is an attitude and view interesting to study; note the relation of parts, as the masses rise one above the other from the feet up. In such a pose, the head and neck are on a line, having a slightly forward tendency; the thorax or upper part of trunk from the false ribs up slopes backward, while the lower part of the trunk and legs collectively are on a line which leans well forward, from the feet up. This subdivides the figure into three masses — the upper terminates at the plane of the shoulders, the second at the diagonal line of the false ribs, the remainder, and by far the largest, terminates with the feet. These three masses are so disposed in their diagonal relation to one another as to produce perfect equilibrium, the straight line which rises vertically from the instep, touches the kneecap, passes just behind the head of the femur, through the pit of the neck and thence through the center of the head. The bony angle of the false ribs as seen in the profile just below the chest marks the most advanced part of the figure, and overhangs all the lower part when standing. In the female, the apex of the breast, however, extends beyond it.

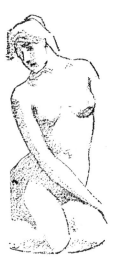

The male figure is widest at the deltoid across the shoulders, and tapers gently to the feet. As in the arm and leg, the body, too, tapers in sections. From the greatest width across the shoulders, the upper part of the body or thorax diminishes in width from the shoulders to the waist only to widen again, first to the crest of the pelvis and then to the head of the femur, from thence the legs collectively taper rapidly to the knees, here the form widens to the calves and diminishes again rapidly to the ankles.

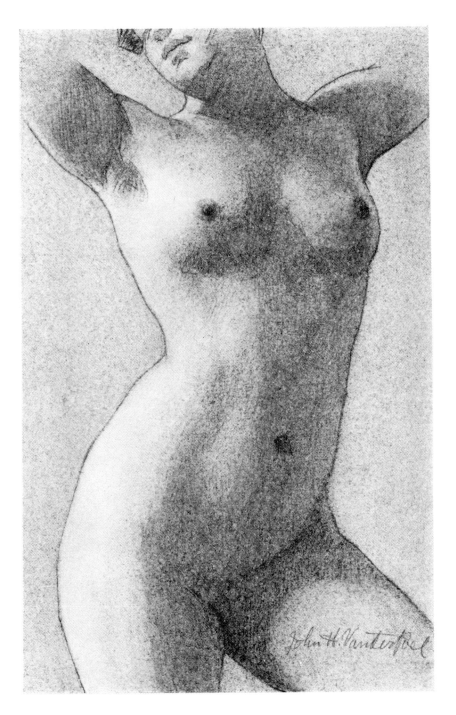

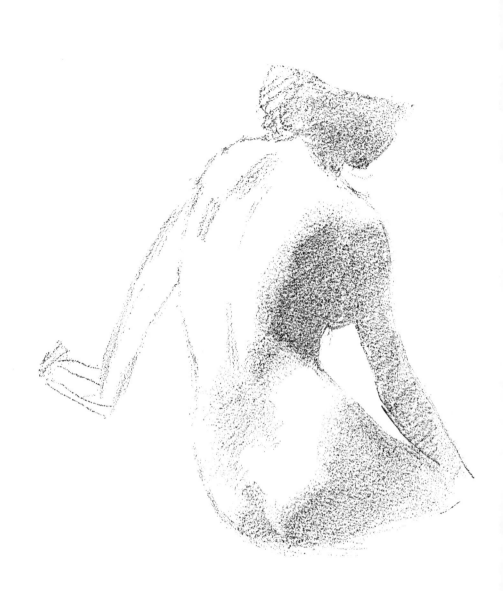

It is well to recall here that the two sides of the body are symmetrical, and one of the greatest charms in the study of drawing lies in tracing this symmetry through all kinds of actions and fore-shortening.

The study of relations and its significance in arriving at proportions should be given the first attention, in seeking the place for the part before the part itself shall occupy his attention. Do not draw the part perfectly until its proper place and relative proportions have been secured; its length, breadth and thickness should first be determined in their relation to the whole figure.

An understanding of the use and location of joints, marking as they do the separation of important parts, is apt to disturb the beginner greatly; the temptation is to halt at a joint, as if it were a half-way house from which to prepare for another form.

If in the drawing of a part it is sufficient that the location of a joint be conveyed on one side only, it is equally sufficient in the early stages of build-

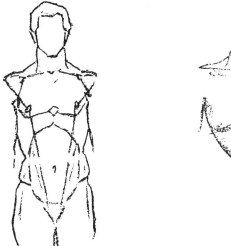

ing up a figure as a whole to mark the local form or action on one side, and convey through the opposite line the big swing or movement that characterizes the pose.

As in the matter of minor forms or planes being submerged in larger ones, so must the movement of minor parts be absorbed temporarily in the great action that expresses the spirit of the pose.

The pose, proportions and construction of the figure should receive our first attention, and be placed to a hair's-breadth, as it were, though in a sketchy way, before the parts themselves are analyzed.

In composing and working from memory or imagination as well as from life, with a vivid mental picture in our vision, it seems almost impossible that other than the salient lines that emphasize the movement and the great planes that envelop the substance should be our first object in beginning the drawing, but only the experienced know the danger and fascination of being lured into the expression of insignificant detail.

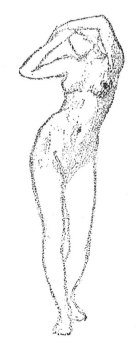

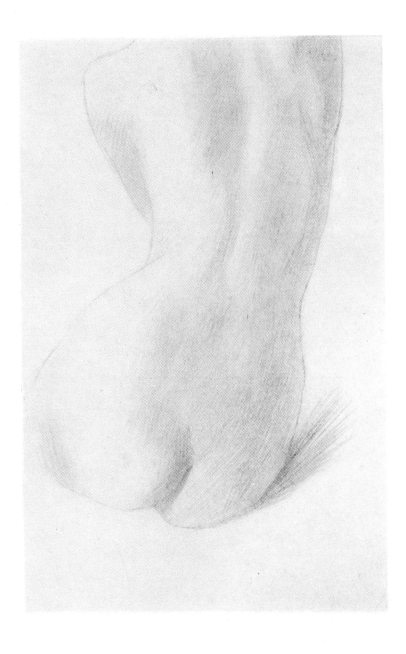

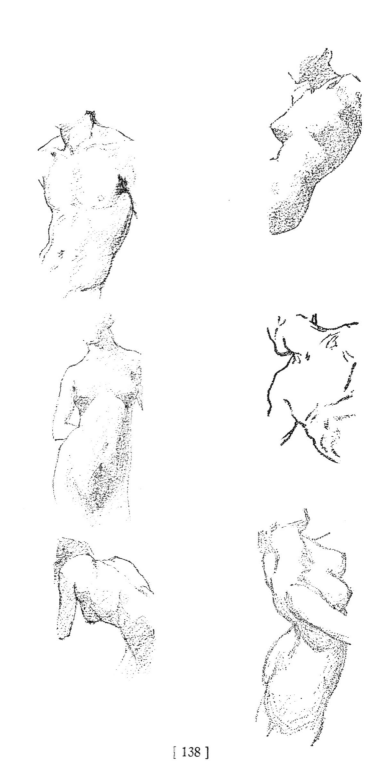

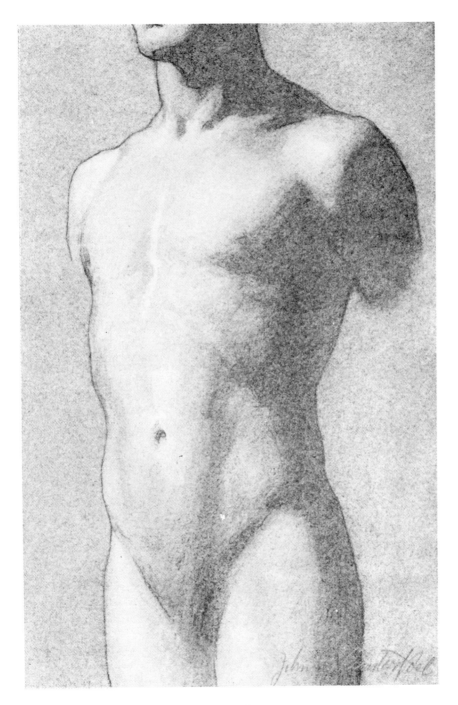

[139]

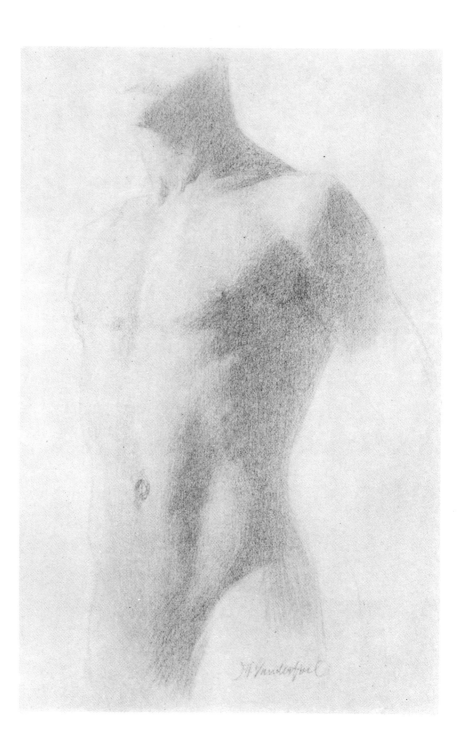

[140]

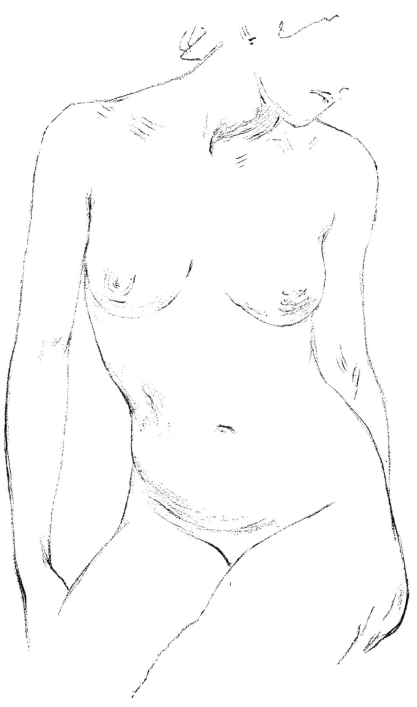

[141]

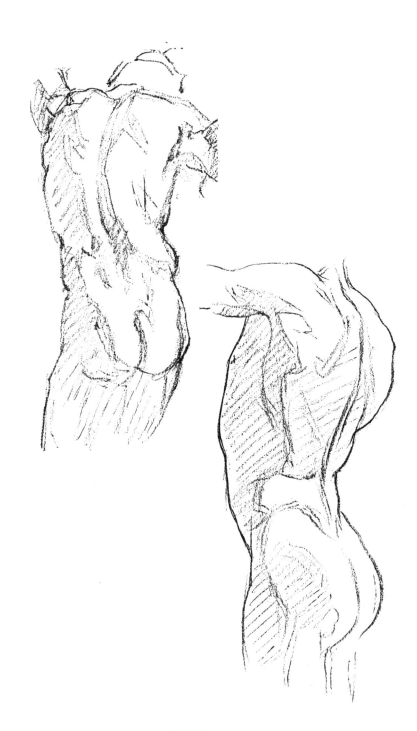

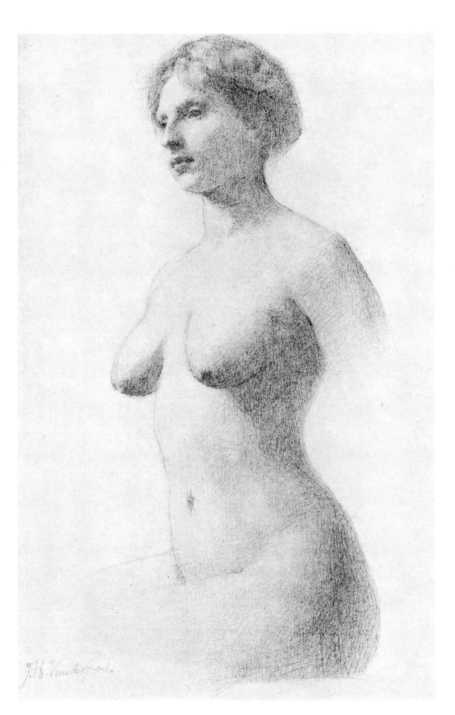